In Loving Memory of Snowball I:

The fleas you left behind keep your memory alive.

THE SIMPSONS™, created by Matt Groening, is the copyrighted and trademarked property of Twentieth Century Fox Film Corporation. Used with permission. All rights reserved.

SIMPSON'S COMICS ROYALE
Copyright © 1994, 1995, 1996, 2000 & 2001 by
Bongo Entertainment, Inc. All rights reserved.
Printed in the United States of America.

No part of this book may be used or reproduced in any manner whatsoever without written permission except in the case of brief quotations embodied in critical articles and reviews.

Published by HarperCollins*Entertainment* 2001

HarperCollins*Entertainment*
An Imprint of HarperCollins*Publishers*
77–85 Fulham Palace Road
London W6 8JB

www.**fire**and**water**.com

ISBN 0 00 711854 6

7 9 8 6

A catalogue record for this book is available from the British Library

Publisher: MATT GROENING
Creative Director: BILL MORRISON
Managing Editor: TERRY DELEGEANE
Director of Operations: ROBERT ZAUGH
Art Director: NATHAN KANE
Production Manager: CHRISTOPHER UNGAR
Production: KAREN BATES, CHIA-HSIEN JASON HO, MIKE ROTE, ART VILLANUEVA
Administration: SHERRI SMITH
Legal Guardian: SUSAN GRODE

Contributing Artists:
EDWIN AGUILAR, HILARY BARTA, KAREN BATES, TIM BAVINGTON, JEANNINE BLACK,
CHRIS CLEMENTS, LUIS ESCOBAR, STEPHANIE GLADDEN, CHIA-HSIEN JASON HO,
OSCAR GONZÁLEZ LOYO, TIM HARKINS, NATHAN KANE, JAMES LLOYD, SCOTT MCRAE,
BILL MORRISON, PHIL ORTIZ, MIKE ROTE, MIKE SAKAMOTO, CARY SCHRAMM, MILI SMYTHE,
RICHARD STARKINGS/COMICRAFT, STEVE STEERE, JR., CHRIS UNGAR, ART VILLANUEVA,
DOUG WHALEY, AND MIKE WORLEY

Contributing Writers:
NEIL ALSIP, JAMIE ANGELL, SCOTT CUNNINGHAM, CHUCK DIXON, SCOTT M. GIMPLE, ROBERT L.
GRAFF, MATT GROENING, STEVE LUCHSINGER, TIM MAILE, JESSE LEON MCCANN, GAIL SIMONE,
MARY TRAINOR, AND DOUG TUBER

Printed in the UK by Scotprint, Haddington.

TABLE OF CONTENTS

THE HITHERTO UNTOLD SECRET ORIGIN OF A CERTAIN NOTORIOUS SPIKY-HAIRED CARTOON CHARACTER

It was 7:29 p.m. on the night of October 4, 1959, and I was one twitchy, quivering five-year-old. I'd just suffered through another lousy episode of "Lassie," which even to a little squirt like me seemed mind-numbingly dull. But now I was starting to bounce on the sofa impatiently, my eyes glued to the big black-and-white TV with the rabbit-ears antenna on top. I could hardly stand the suspense! Come on, come on!

I was waiting for the premiere episode of what no doubt was going to be the finest TV show in the history of the universe: "Dennis the Menace."

Finally! A show about a kid I could relate to:

A show about a kid who was bad! Who had his own slingshot! Who sassed back to grownups! Who was naughty! Who stole cookies! Who didn't do his chores! Who was not just a wisenheimer, not just a hooligan, not just a smart-aleck, not just a juvenile delinquent, but a . . . menace!

And then the show began, and my eyes bulged. The opening titles were animated—and what animation! Dennis the Menace wasn't merely the cute little scamp from the daily comic strip—he was a whirling, rampaging tornado, causing destruction wherever he went. I was in heaven.

But then the story started, and with it came the big letdown. It showed a well-scrubbed little boy who was mildly vexing to adults, mainly because he talked a little too loud. That was it. I think it was supposed to be a comedy—the laugh track was turned way up—but nothing funny was shown. Once again TV had betrayed me. I watched about half the show and then sadly turned the channel to "Maverick."

But I never forgot that primal thrill of seeing the little cartoon tornado, which must've been on the screen for less than thirty seconds. I filed that moment away in the back of my brain and pretty much forgot about it.

And then in 1987 I got my own shot at creating a cartoon for TV.

Hmmm, I pondered . . . Tornado-boy . . . naughty punk . . . spiky hair . . . slingshot . . . here comes trouble . . . a brat . . . a brat who's actually a brat . . . I think I'll call him . . . transpose a couple letters . . . and voilà! **Bart!**

Your pal,

MATT

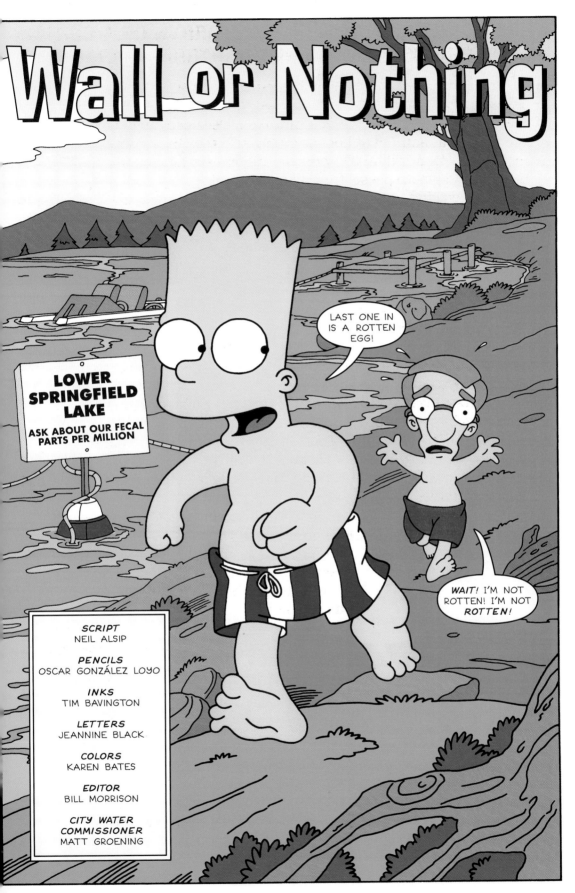

Wall or Nothing

LAST ONE IN IS A ROTTEN EGG!

WAIT! I'M NOT ROTTEN! I'M NOT ROTTEN!

LOWER SPRINGFIELD LAKE

ASK ABOUT OUR FECAL PARTS PER MILLION

SCRIPT
NEIL ALSIP

PENCILS
OSCAR GONZÁLEZ LOYO

INKS
TIM BAVINGTON

LETTERS
JEANNINE BLACK

COLORS
KAREN BATES

EDITOR
BILL MORRISON

CITY WATER COMMISSIONER
MATT GROENING

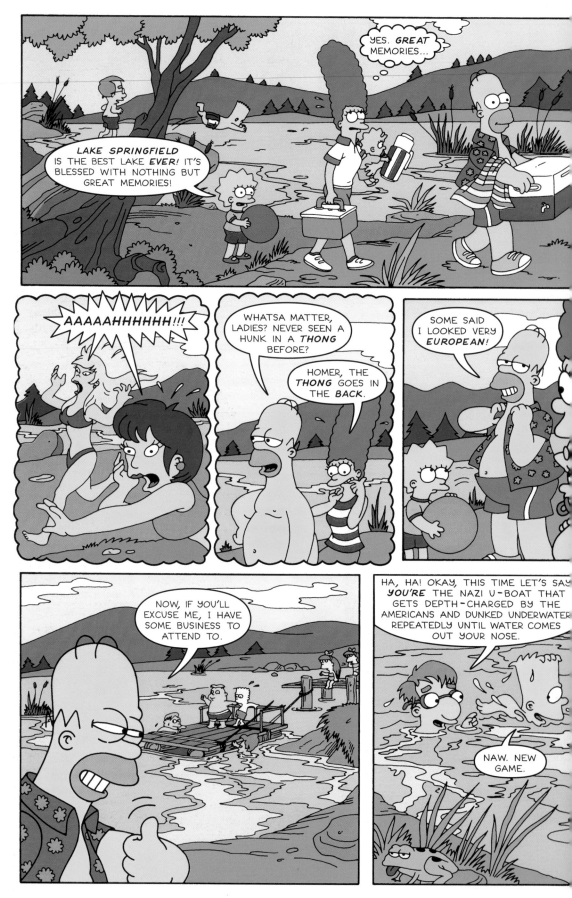

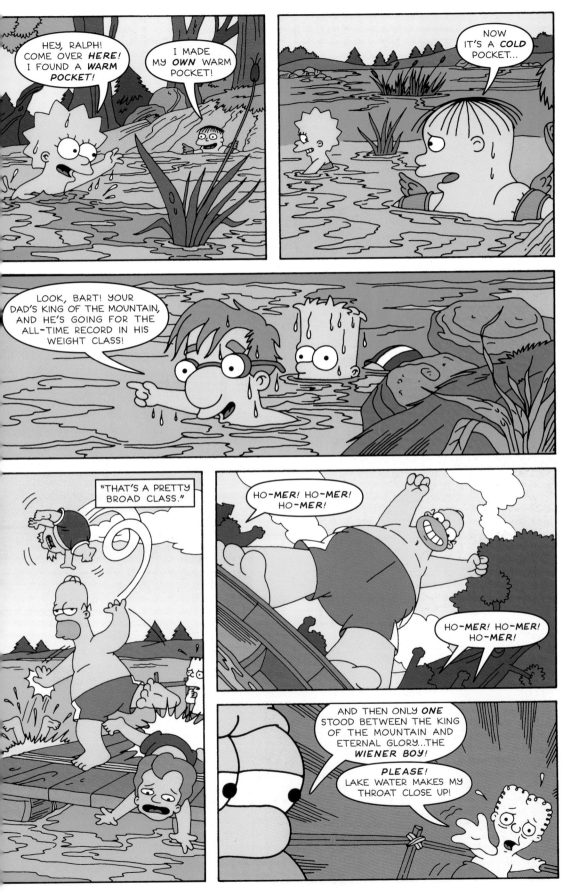

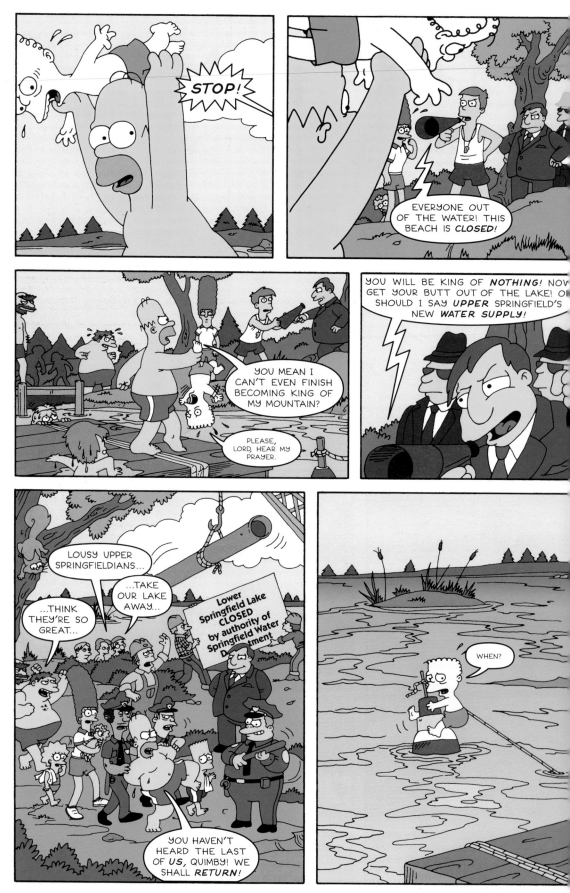

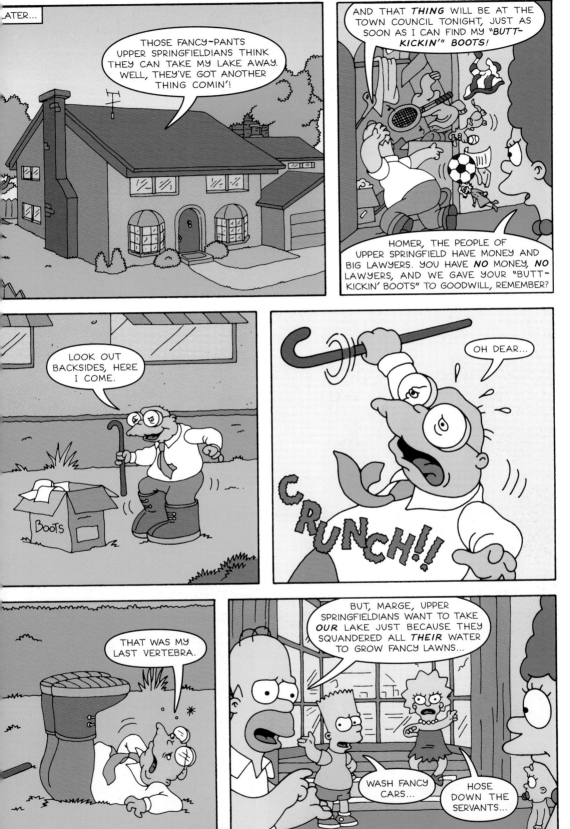

9

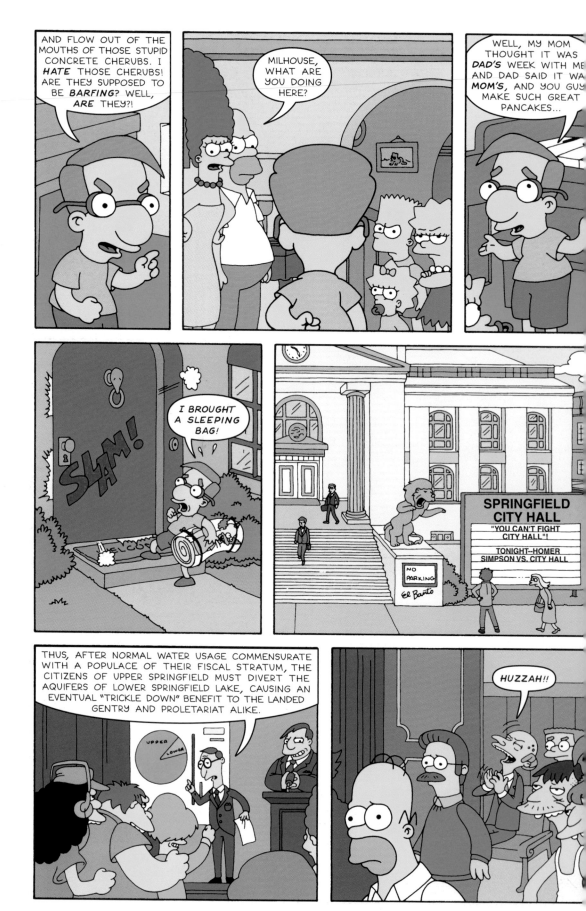

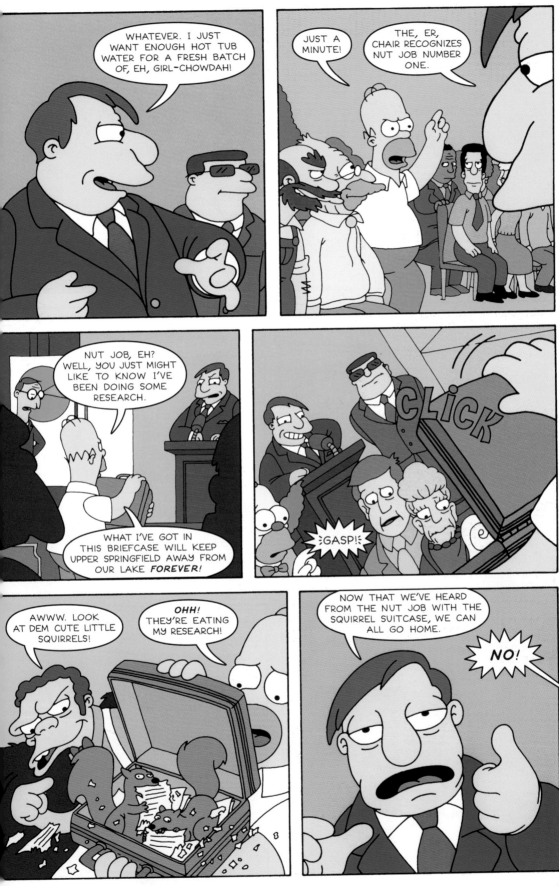

I'VE BEEN DOING MY *OWN* RESEARCH INTO SPRINGFIELD'S WATER RIGHTS, AND WHEN I'M DONE, I'D LIKE TO SEE WHAT YOU ALL HAVE TO SAY!

BURN HER!!

OH, WHEN SHE'S *DONE* TALKING.

JEBEDIAH SPRINGFIELD HAD TWO STRAPPING YOUN[G] SONS, ZECHARIAH AND OBADIAH, WHO HAD AGREE[D] TO RUN SPRINGFIELD AS A TEAM IN THE EVENT OF THEIR FATHER'S PASSING.

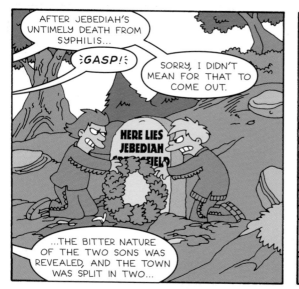

AFTER JEBEDIAH'S UNTIMELY DEATH FROM SYPHILIS...

:GASP!:

SORRY, I DIDN'T MEAN FOR THAT TO COME OUT.

HERE LIES JEBEDIAH [SPRING]FIELD

...THE BITTER NATURE OF THE TWO SONS WAS REVEALED, AND THE TOWN WAS SPLIT IN TWO...

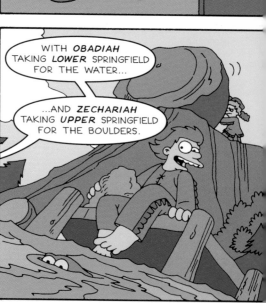

WITH *OBADIAH* TAKING *LOWER* SPRINGFIELD FOR THE WATER...

...AND *ZECHARIAH* TAKING *UPPER* SPRINGFIELD FOR THE BOULDERS.

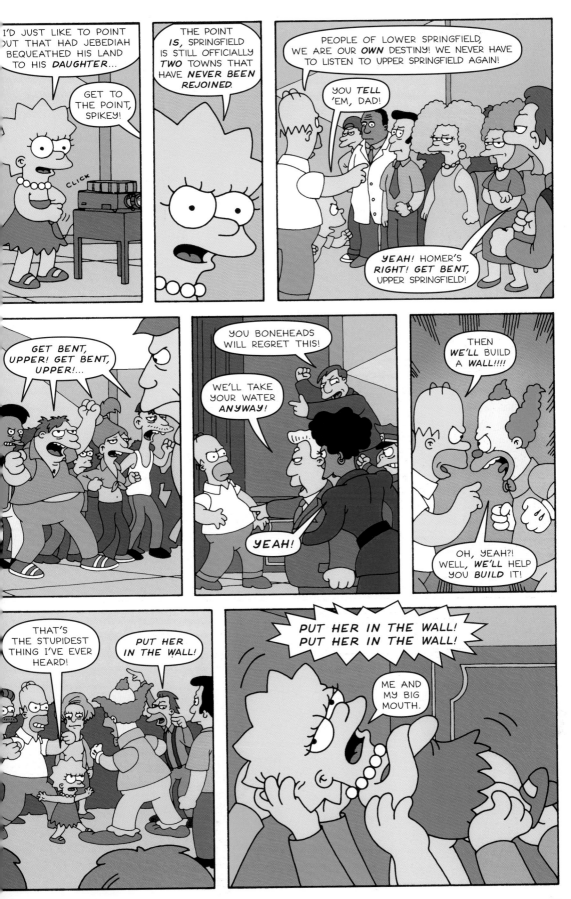

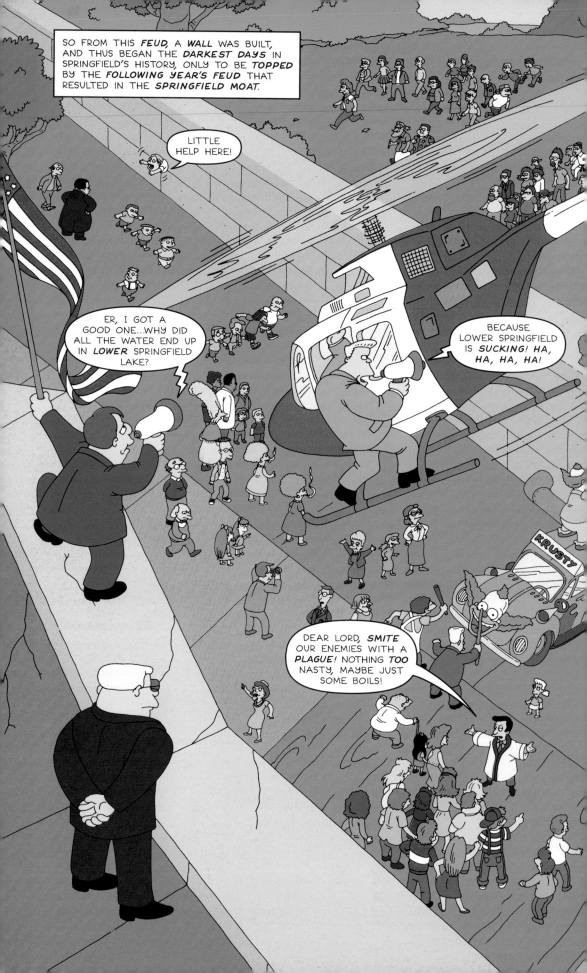

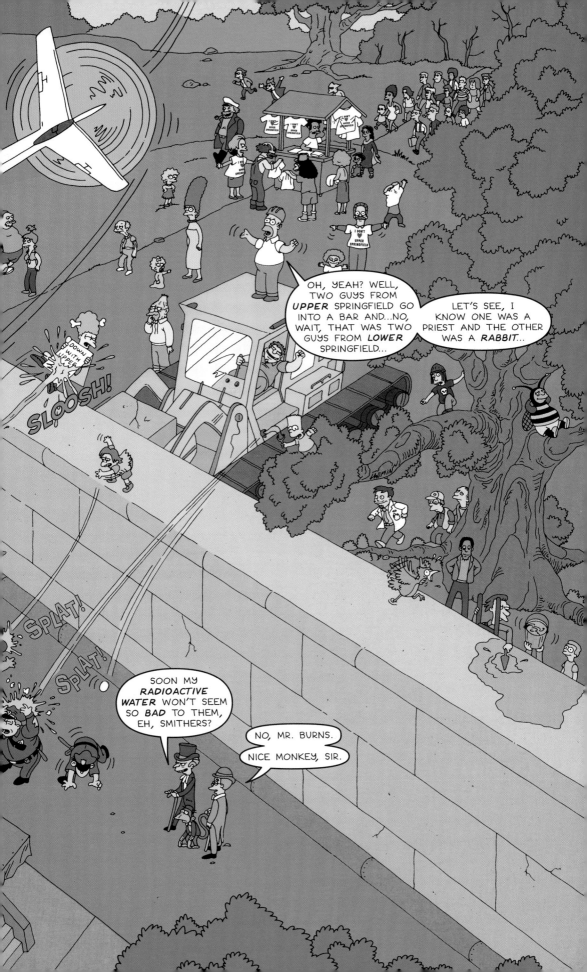

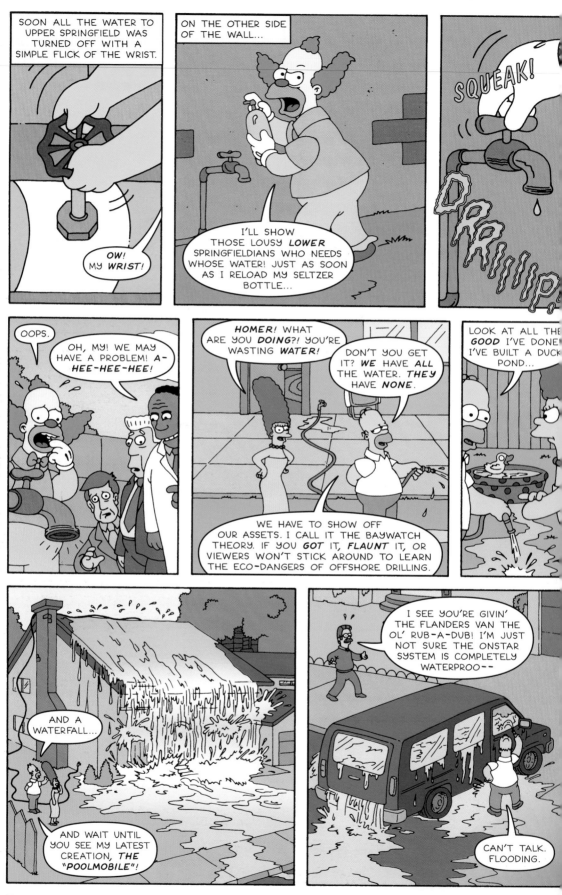

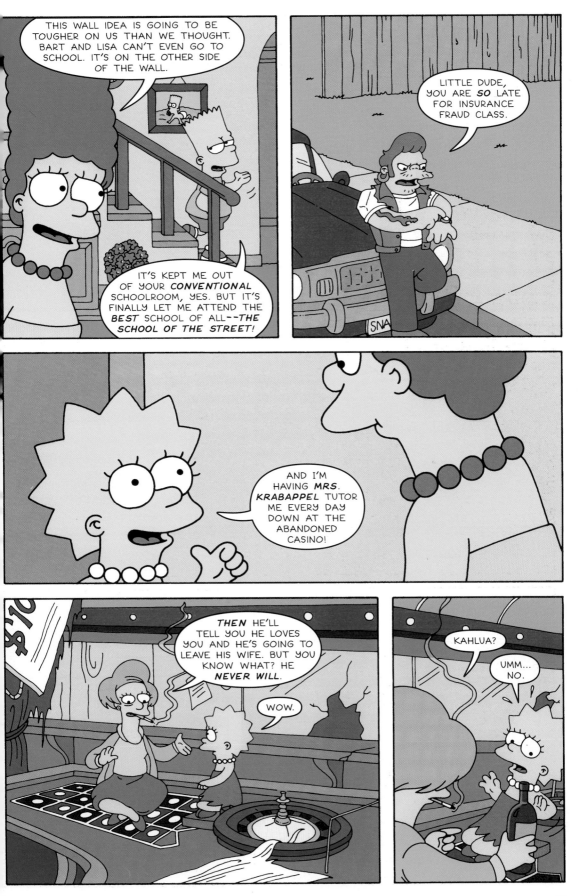

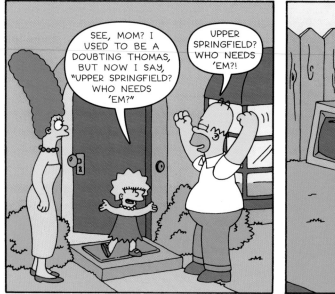

SEE, MOM? I USED TO BE A DOUBTING THOMAS, BUT NOW I SAY, "UPPER SPRINGFIELD? WHO NEEDS 'EM?"

UPPER SPRINGFIELD? WHO NEEDS 'EM?!

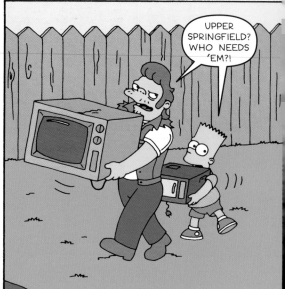

UPPER SPRINGFIELD? WHO NEEDS 'EM?!

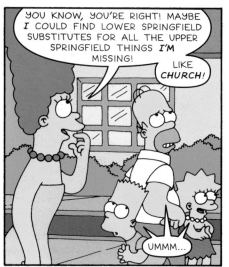

YOU KNOW, YOU'RE RIGHT! MAYBE *I* COULD FIND LOWER SPRINGFIELD SUBSTITUTES FOR ALL THE UPPER SPRINGFIELD THINGS *I'M* MISSING!

LIKE *CHURCH*!

UMMM...

RETIREMENT CENTER CHAPEL SERVICE

TODAY:
WHY YOUNG PEOPLE ARE EEEEEEVIL

"...AND ALL OF MAN'S VILLAINY SHALL BE PLACED UPON THE HEAD OF THE GOAT." SO SAYETH THE BOOK OF LEVITICUS.

THAT'S IN *HOSEA*!

LEVITICUS!

HOSSSSEEEEEEEA!

MAYBE THIS WAS A BAD IDEA...

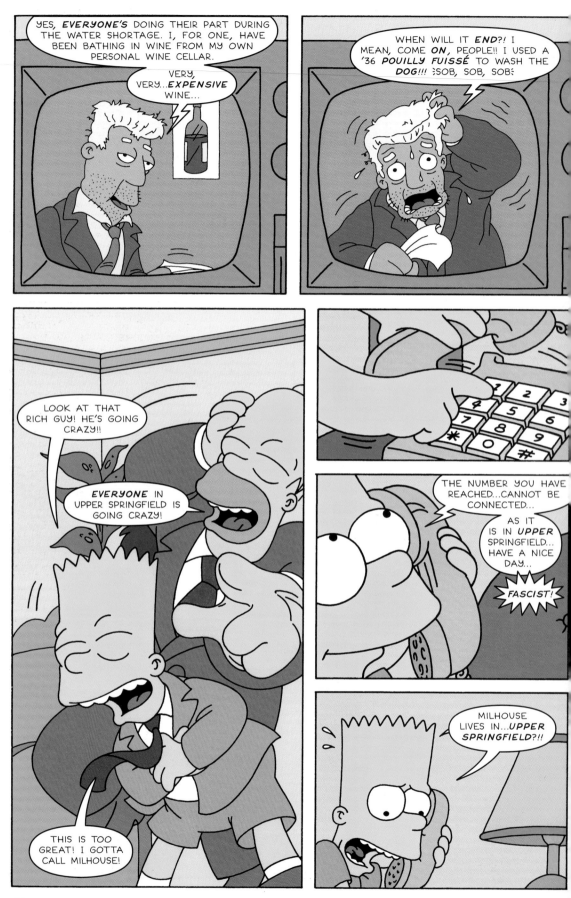

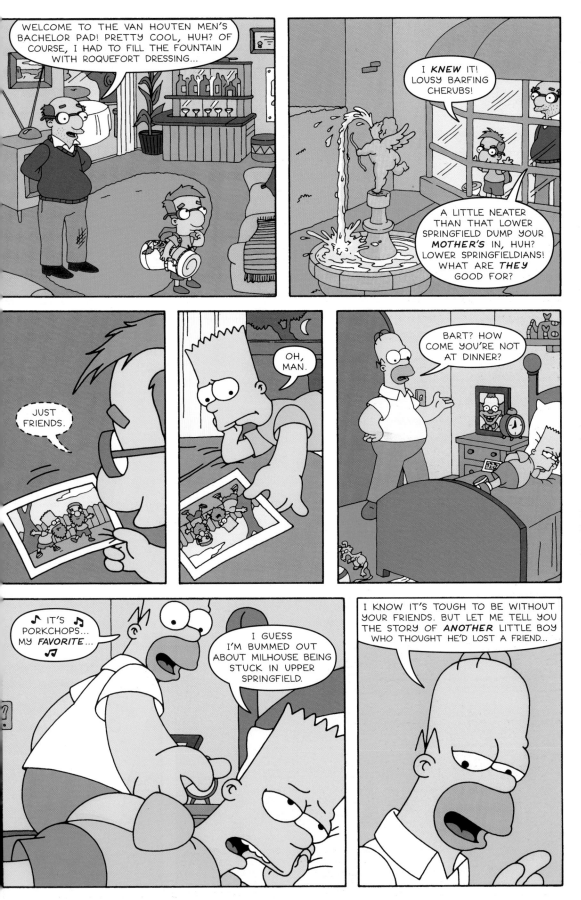

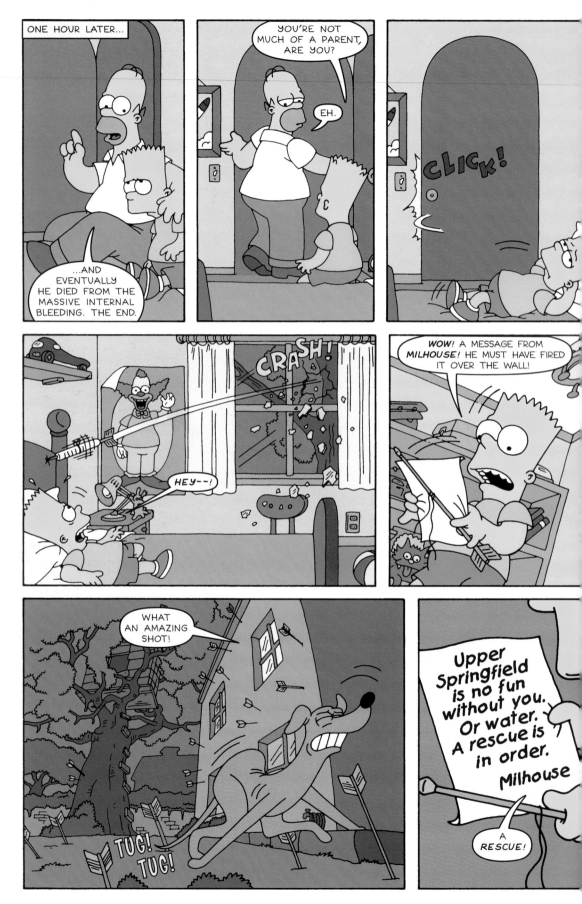

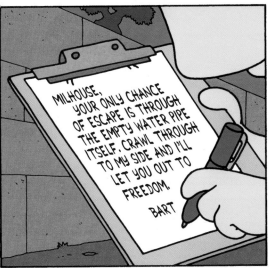

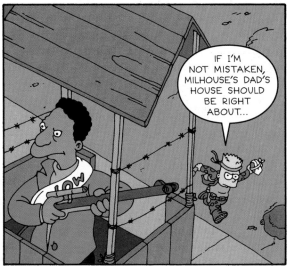

24

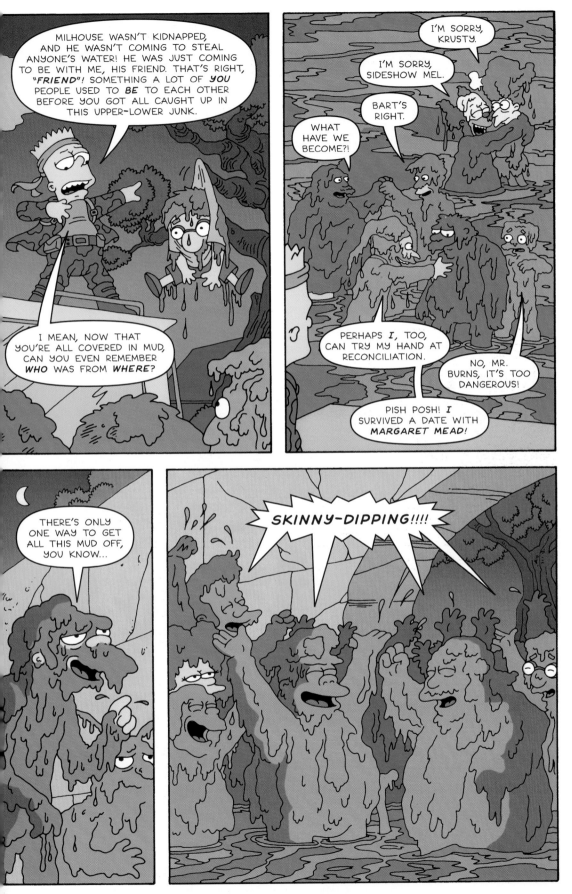

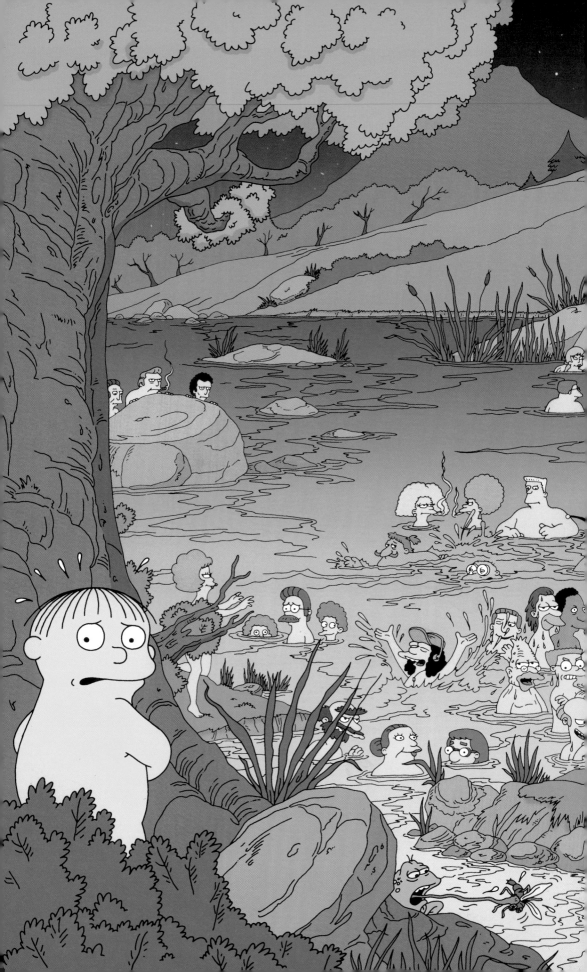

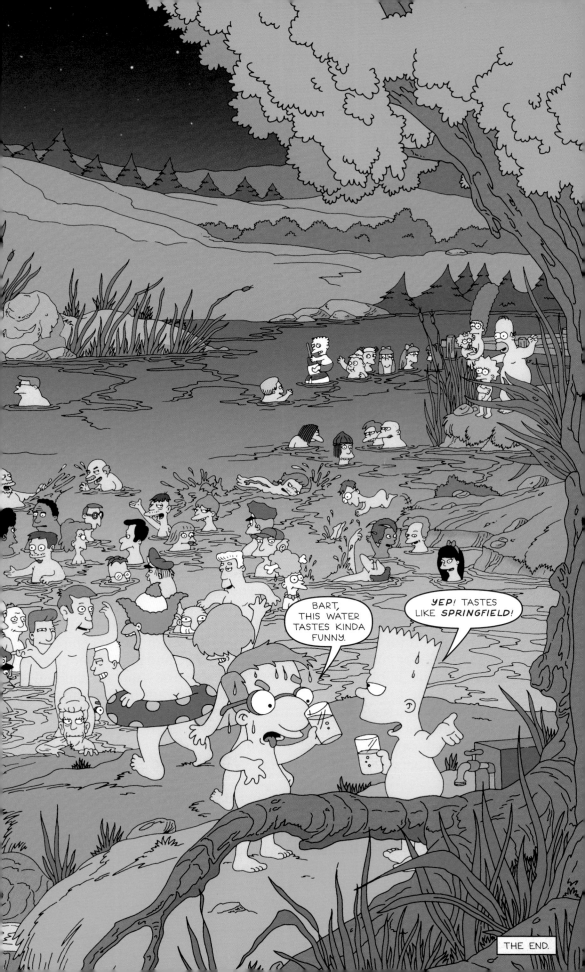

ADVICE TO YOUNG CARTOONISTS

When you're a pesky young whippersnapper, sometimes you find yourself being forced to listen to some grizzled old geezer prattle on and on and on about something of no importance to you. There's no escape. You just gotta sit there patiently and try to look awake, because the old duffer is obviously starting to lose it, and you don't want to hurt his senile feelings. Plus the old fossil looks kinda cranky, and maybe he'll smack you with his cane just 'cause he gets it in his feeble brain that you're some kinda smartass.

You think, okay, maybe this old dude just forgot what it was like to be a kid with more important things to do. Or more likely, maybe this old codger does remember what it was like to be young, but he figures, hey, when I was a kid I had to listen to my elders, so now that I'm an old poop myself, by gum, them kids're gonna listen to me! It's my turn, dagnabbit!

That's sorta how your ol' Uncle Matt feels right now.

So just imagine me leaning back in my big office chair, with my thumbs under my suspenders, clearing my throat disgustingly, and offering the following pearls of wisdom about cartooning.

1) Don't draw with cheap felt-tip pens. The ink in drawings made with felt-tip pens will fade in a few years, and all you'll be left with is a bunch of ghostly images, then nothing at all. And these drawings fade even faster when exposed to sunlight. So wise up and use pens with permanent ink, and try to draw on paper that's not going to get yellow and fall apart. (I learned this the hard way.)

2) Finish your work! Drawing complete stories is really hard, especially when you're a kid, but there's nothing like having a finished story—with beginning, middle, and end—to amuse yourself and your friends. Unfinished work just doesn't cut it.

3) Save your stuff! Often, as your drawing and writing skills develop, or you get older and start having other, more "mature" interests, your earlier cartoon work starts looking lame and clumsy. The usual urge is to toss it—but resist that urge! I guarantee that later in life you'll be glad you held on to your cartoons, no matter how stupid they look now.

4) Don't let your mom throw your cartoons out! Moms have a tendency to do this. You go off for a weekend visit to Aunt Gladys, or you get shipped off to summer camp, or you turn your back for a second, and poof! There go your toys, your comic books, and your brilliant artwork. And no amount of squealing is going to bring that stuff back. So take care of your treasures--keep 'em out of the way of anyone who has some weird hatred of "clutter"--and make sure that everyone in your family knows you're insanely possessive of your stupid, worthless junk. If you make your stand early, before permanent damage is done to your goodies, they may learn not to mess with your mess.

5) It's okay to copy other cartoons, but it's easy to get obsessed with a particular style that you can never master. I spent a solid year trying to draw Batman when I was eleven, and have nothing to show for it but a bunch of crummy-looking, vaguely Batmannish ghosts (see Item #1). So my advice is to copy from a whole bunch of different sources—eventually you'll figure out a style that fits you.

6) Get a sketchbook. Do lots and lots of drawings. Fill up the sketchbook. Repeat.

7) Most how-to-cartoon books are terrible, so don't get discouraged by their lousy advice. Remember, if the people who put together how-to-cartoon books knew what they were doing, they probably wouldn't be doing how-to-cartoon books.

8) Check out the original artwork of cartoonists you admire. You may be in for a surprise. It doesn't look as slick as the printed stuff, does it? It's full of smudges, pencil marks, erased lines, and covered-up mistakes. Most young, would-be cartoonists end up getting totally bummed out because their stuff doesn't look as slick and perfect as the stuff they see in print. But the original work by the pros themselves usually doesn't look that good, either. So it's okay for your original artwork to look a little smudgy, too.

9) It's not horrible to be a crummy drawer. There's room for all sorts of styles in the world. All I can draw are people with big eyeballs and no chins, and I can't even do that too well—but look at me. I get to blab about how to cartoon, and you get to listen to me.

10) And finally: Be original. It's okay to copy the cartoons you love, if you must. But please: Eventually edge toward your own ideas and stories. That way I won't have to track you down and sue you.

Your pal,

MATT

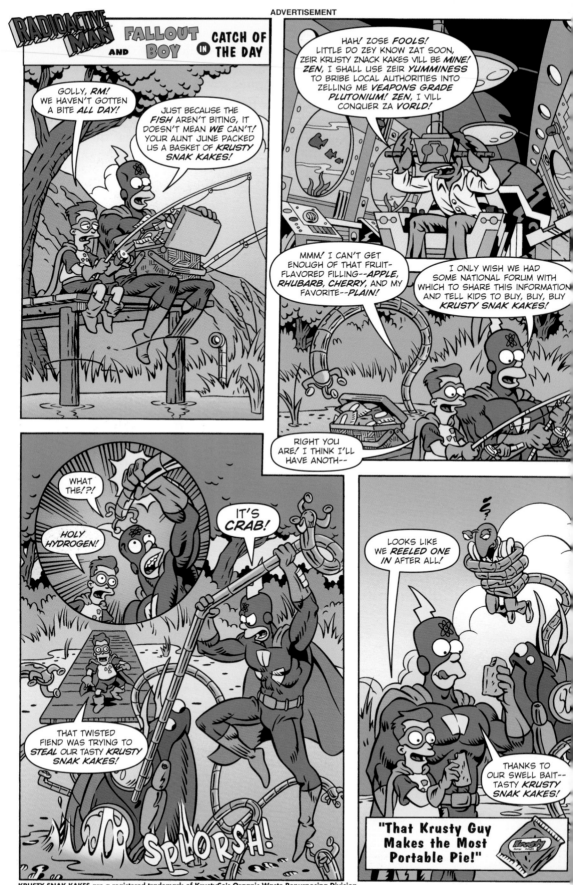

KRUSTY SNAK KAKES are a registered trademark of KrustyCo's Organic Waste Repurposing Division.

KRUSTY & MR. TEENY IN DOUBLE DATE

DON'T BE A CHUMP SMOKE CHIMP CIGARS

Springfield VARIETY — KRUSTY KING!

BAR

LOOK YOUR *BEST* FOR THE *PREMIERE* TONIGHT, LADIES . . . MY *CAREER* IS RIDING ON IT!

PICK YOU UP AT 8. CIAO, BABES!

I DON'T *CARE*, MISTER TEENY, WEAR WHATEVER YOU *WANT*.

STUPID CHIMP.

WEAR WHAT YOU WORE THE NIGHT YOU *SWAM* IN *SINATRA'S* PUNCHBOWL.

REMEMBER THE *3 RULES* FOR *TONIGHT*, MISTER TEENY: 1) DON'T *UPSTAGE* KRUSTY! 2) DON'T *BOTHER* KRUSTY'S DATES! 3) DON'T *EAT* KRUSTY'S FLOWERS!

SCRIPT: **JAMIE ANGELL** LAYOUTS: **CARY SCHRAMM**
PENCILS: **LUIS ESCOBAR** FINISHED ART:
TIM BAVINGTON COLOR: **DOUG WHALEY**
ASSISTANT TO MR. TEENY: **MATT GROENING**

34

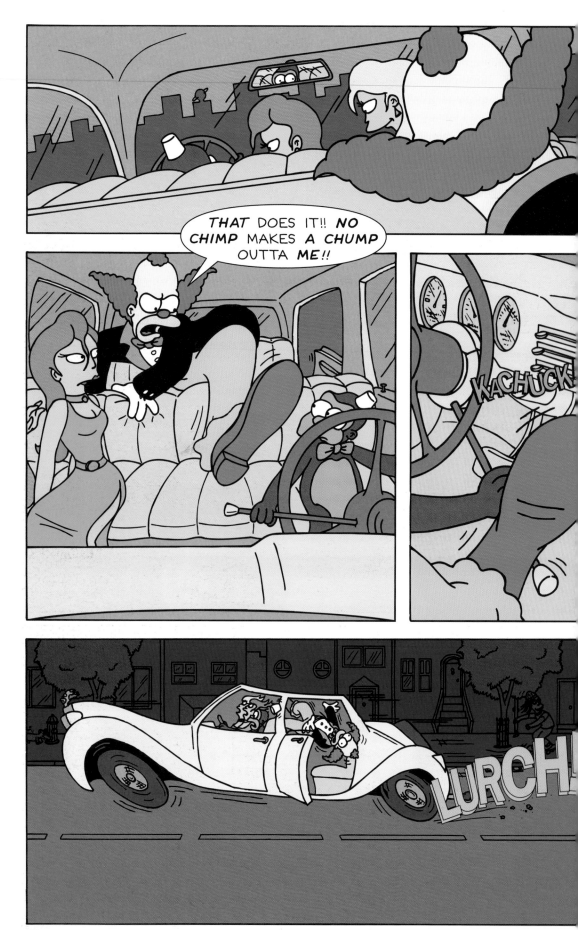

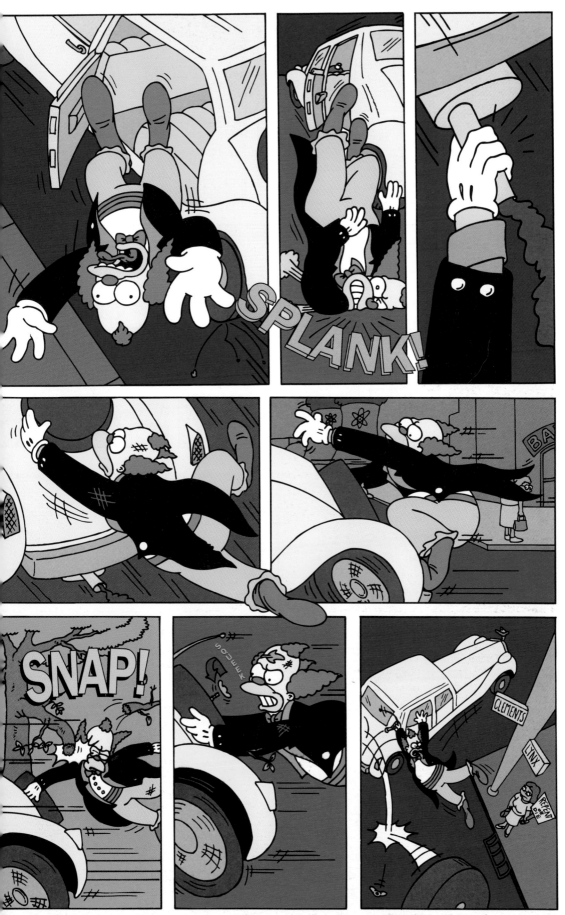

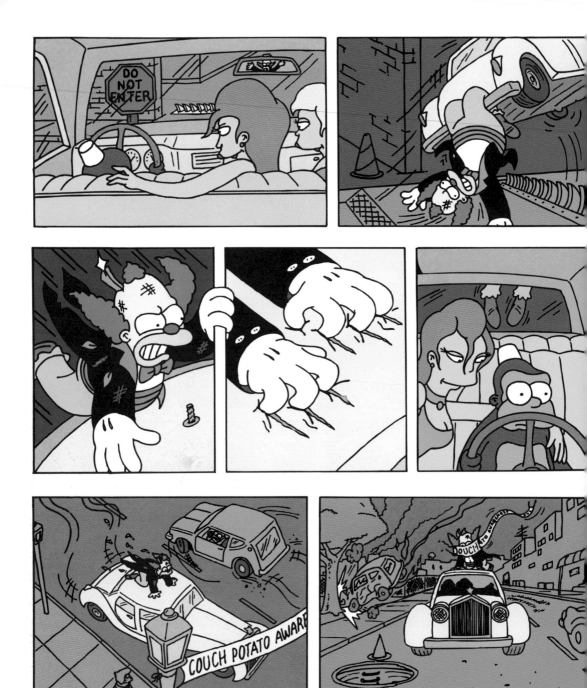

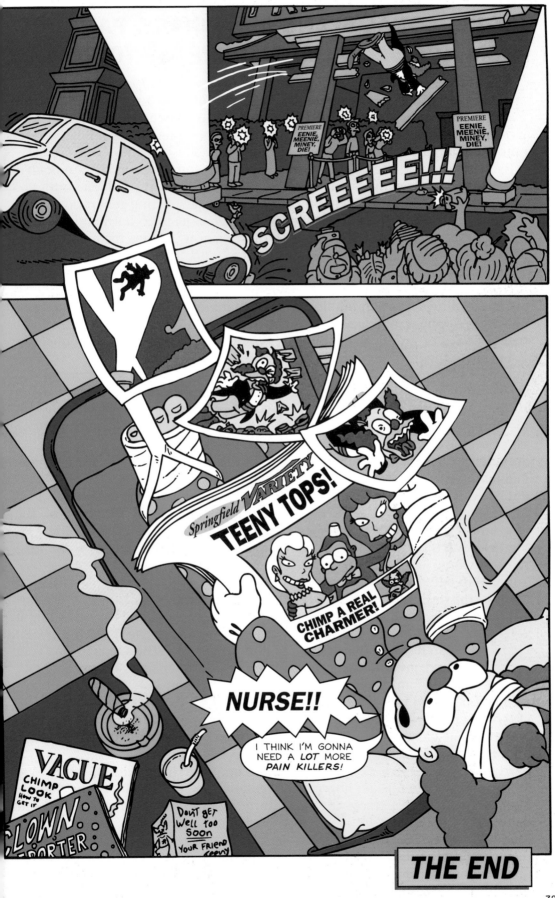

THE END

MY PERSONAL SLANG DICTIONARY, PART ONE: FROM *ACCIDENTALLY ON PURPOSE* TO *GROOVY*

One of the great things about being a kid is having your own slang—words and phrases you 'n' your hepcat droogs dig but which really hack off the geezers. Put another way, it's "nifty" when you slam down some mean morphin jim-jam, because the ancient nibblers have their offendo-snort-bags set for automatic inflato-mode.

Back in the early, prehistoric days of Bart Simpson (circa 1987), I took vivid yet cornball slang expressions that I remembered from my golden youth and tried to see if I could palm 'em off on younger, unsuspecting generations. I did this because making up new-fangled slanguage is just too hard and, besides, sounds ultra-fakey. That's where "Don't have a cow" comes from—the misty, addled memories of my feverish youth. Just add "man" to the phrase, and voila!—you have an immortal Bart Simpson catch-phrase: Don't have a cow, man.

What follows is a mini-glossary of back-of-the-classroom mumbles, playground jabber, and assorted outdated slang words and phrases from the bad old days of my foolish childhood. Some are obvious, some are obscure. Feel free to incorporate them into your own troubled lives, kids.

accidentally on purpose: As if inadvertently, but actually by intention. Used in response to a perpetrator's lame excuse: "I swear it, man. I didn't mean to pour the syrup on Billy's head. I did it accidentally." "Yeah, right—accidentally on purpose." (Everybody then laughs, except Billy.)

acey-deucy: Really stupid card game my pals and I played in high school, mainly because we found poker too complicated.

aw, shucks: A mild exclamation of embarrassment or awkwardness, used ironically by boys to demonstrate an awareness of the silliness of the discomfort being expressed. Used incorrectly, comes off as phony-baloney.

big deal: Anything extremely important. Used in a strictly ironic sense as a retort to some jerk's bragging: "Look! I got an A on my Civics test!" "Big deal. You're still ugly."

the bus, the bus, the b-u-s!: A dorky chant taken up by young kids at the bus stop, started by the first little squirt to see the bus coming. Very satisfying if you're six years old and you've just learned how to spell the word "bus." The chant is repeated till the bus arrives, or until a bigger kid threatens to slug you.

cool: Nice, good, great, or excellent. Warning: I started using this word when I was seven, and am ashamed to say I've never been able to stop. All-too-frequent personal variant: cool, man.

crusty: 1. Of inferior quality. 2. Disgusting, loathsome. 3. Unfair. Example: "My dad made me clean out this rusty old drain pipe that had a dead squirrel stuck in it. Isn't that crusty?"

dead meat: 1. A person about to be beaten up: "You're dead meat, man!" 2. A feeling of doom before an important event, such as a test: "We're dead meat, man." 3. A fatigued person after an afternoon of crusty chores. "Whew! I'm dead meat." Poetic variant: dead meat on a stick.

dine and dash: The teenage game of eating a meal in a restaurant, then departing without paying. One game variant involves leaving a single unsuspecting pal at the table at the end of the meal, sneaking out, then tapping

on the window from outside and waving goodbye. Also known as: 1. Eat it and beat it. 2. Masticate and motivate.

doomed: The unpleasant feeling associated with being dead meat (see above).

dorky: Stupid, goofy, awkward. Used dismissively but occasionally with some affection: "When you fell down the stairs on your skateboard you sure looked dorky, man."

eat my shorts: An exclamation of defiance and contempt. Properly used while sneering. Disgusto variant: Eat my crusty shorts.

five-finger discount: Shoplifting. In the Simpsons universe, of course, it's four-finger discount.

flash on you and your mama too: Another exclamation of defiance and contempt. I only vaguely recall this phrase, but cartoonist pal Lynda Barry says it was big in her Seattle neighborhood when she was a kid. (Read Lynda's "Ernie Pook's Comeek" for more cool words and phrases, man.)

forget you: An exclamation of rejection or refusal. A slightly more personal, insulting way of saying "no way." Best said in a whiny tone. For that matter, almost all the insulting words in this glossary sound better if you whine 'em, and gain even more strength if you whine 'em with your upper lip curled and some of the sounds coming out of your nose. Makes you sound snotty, a highly annoying and therefore desirable trait in kids.

get out: An exclamation of utter disbelief. Example: "I saw Billy kissing a dog yesterday." "Get out!"

goody-goody: A kid who follows the rules in a way calculated to make kids who don't follow the rules get violent against the kid who follows the rules.

groovy: Excellent, enjoyable, wonderful. Used by my buddies only with dripping adolescent sarcasm. Occasionally pronounced "guh-roovy."

(To be continued . . .)

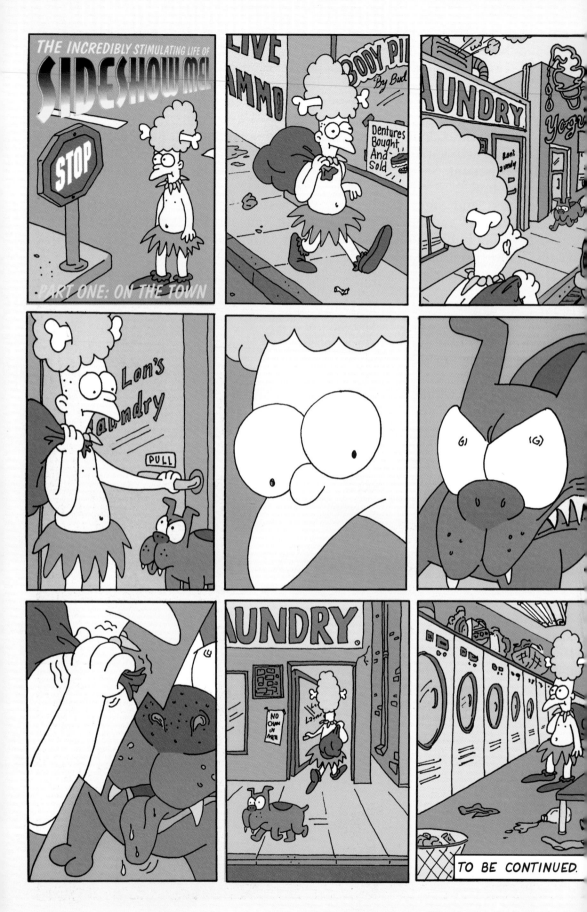

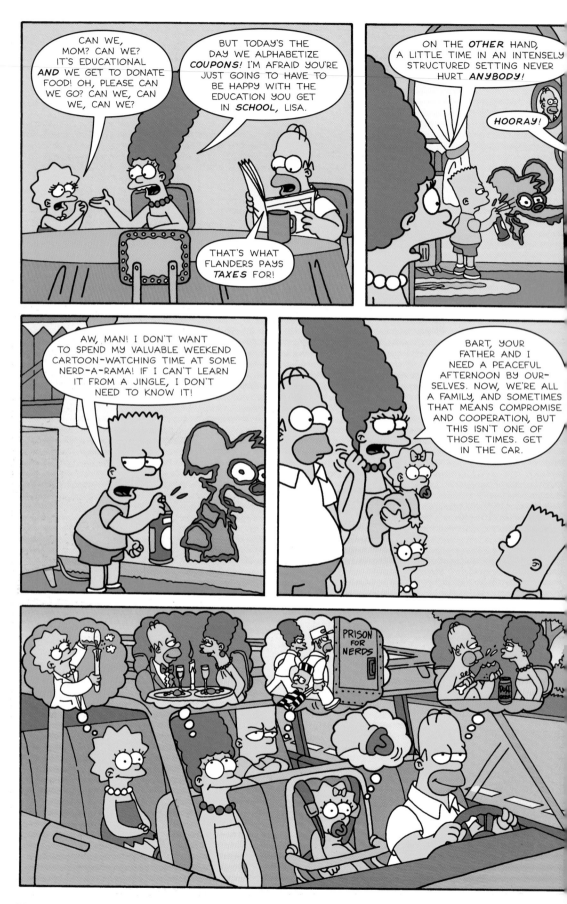

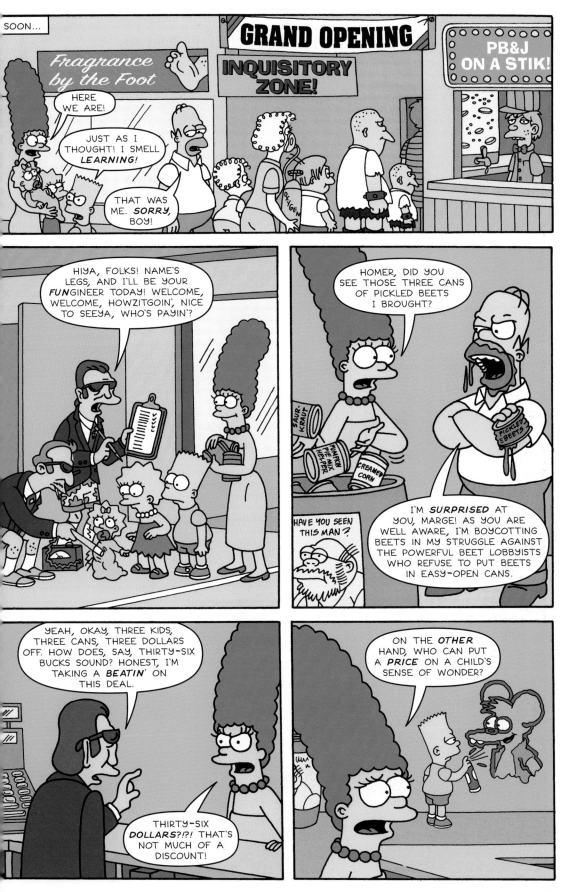

45

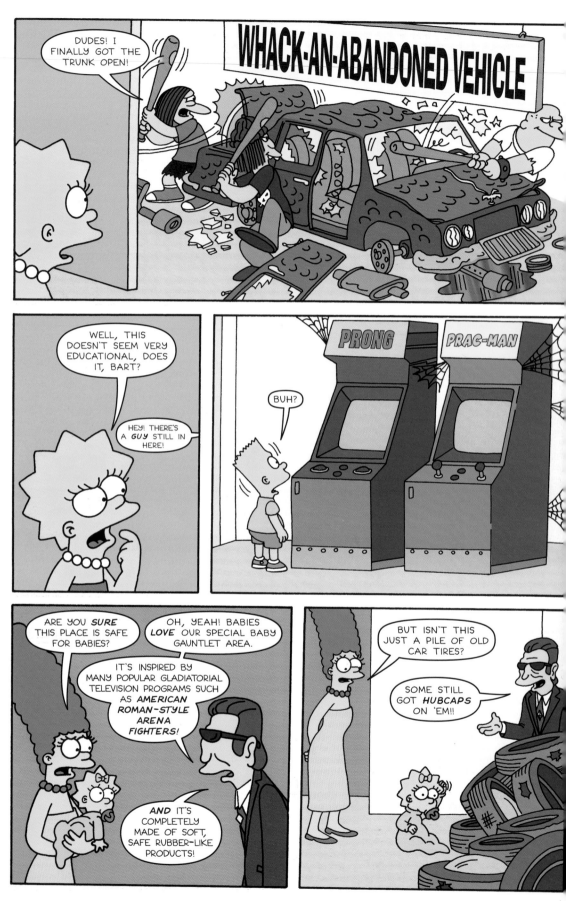

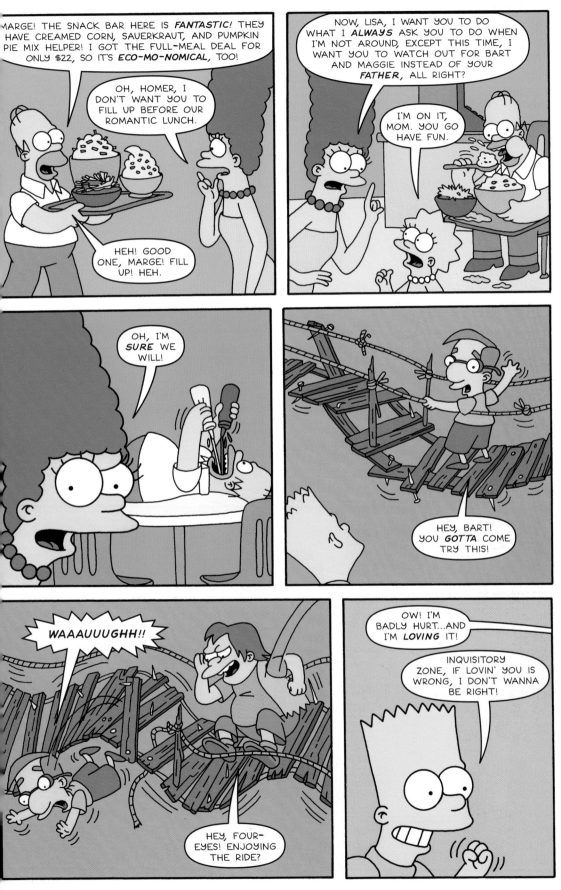

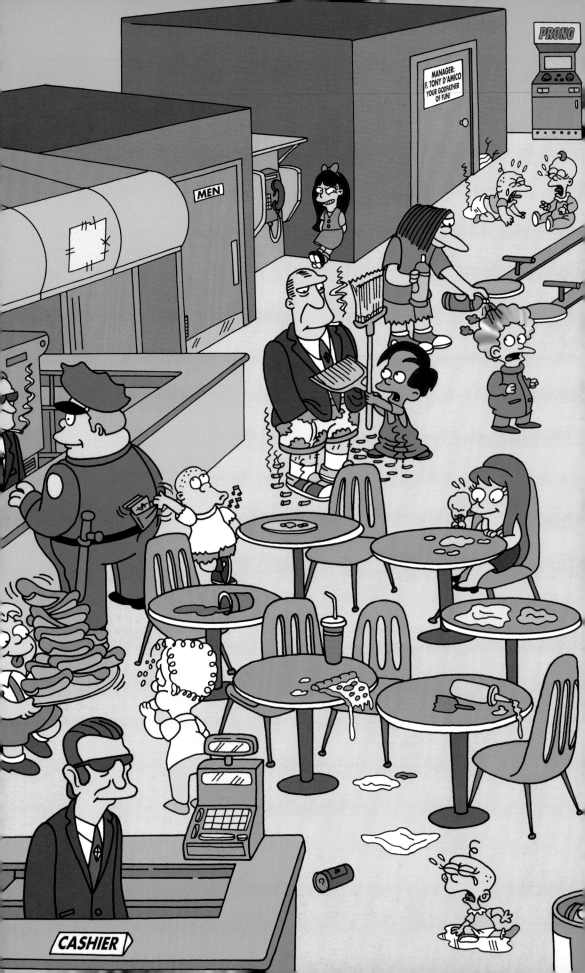

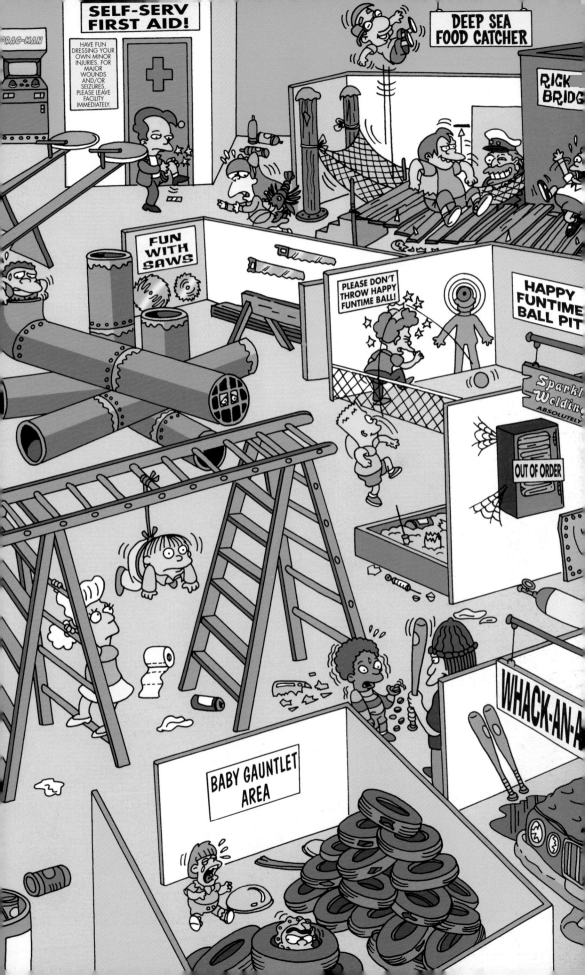

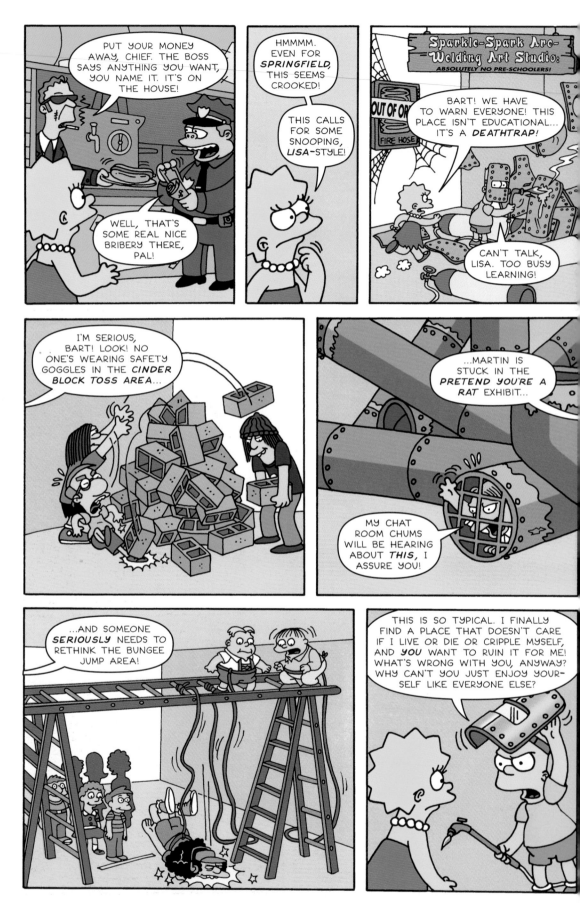

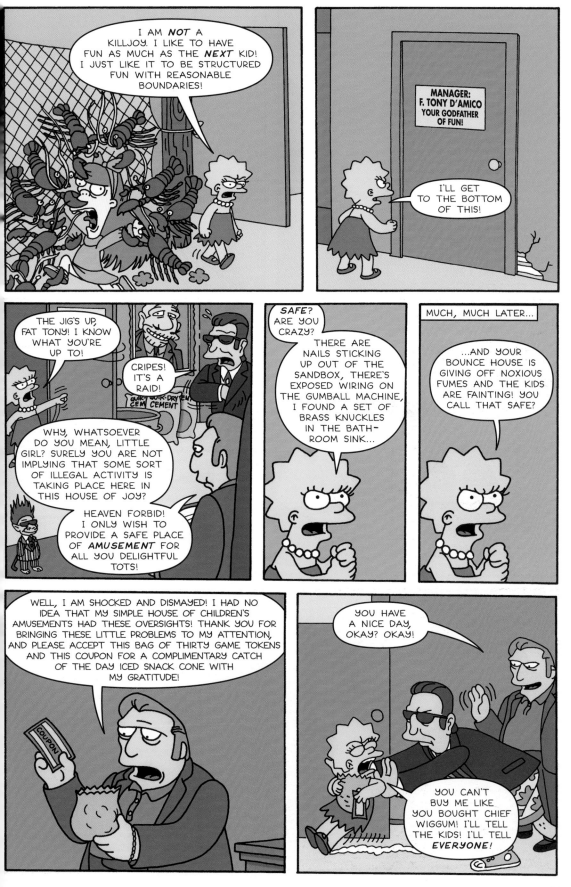

51

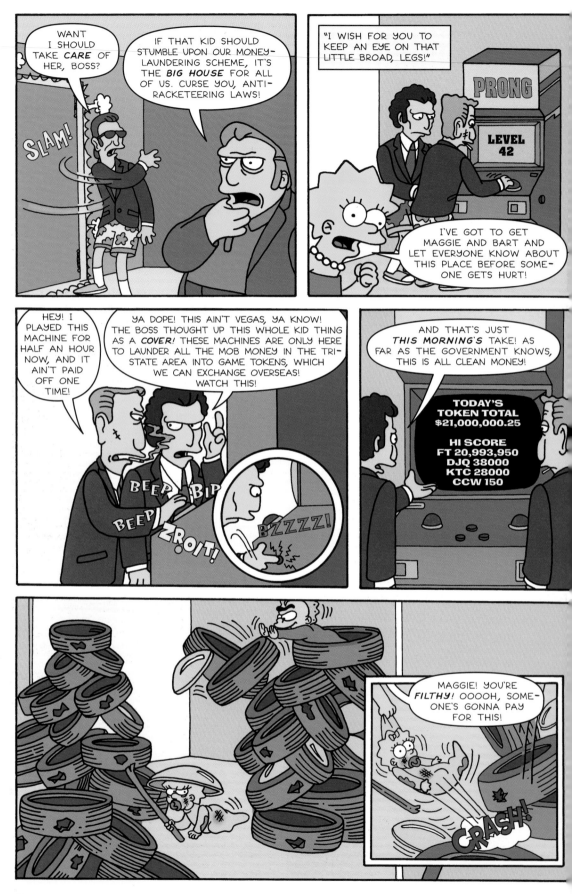

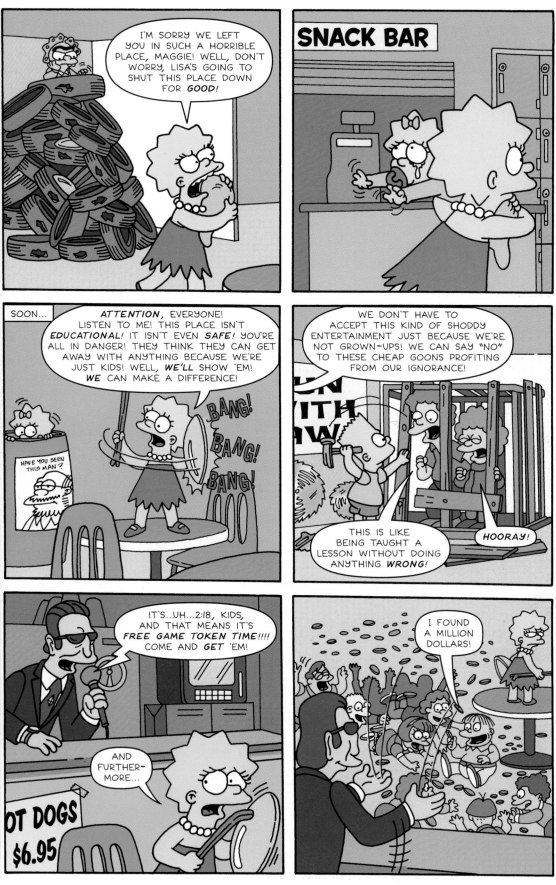

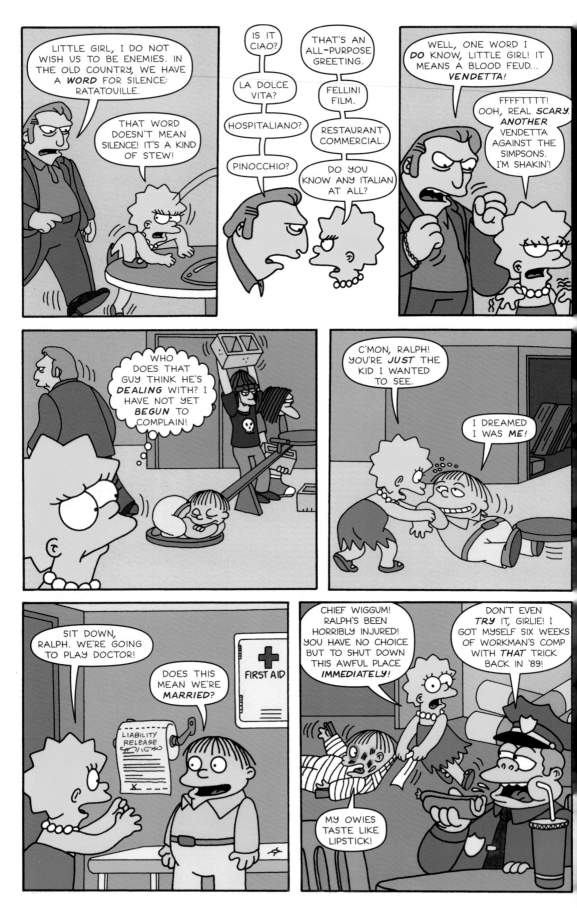

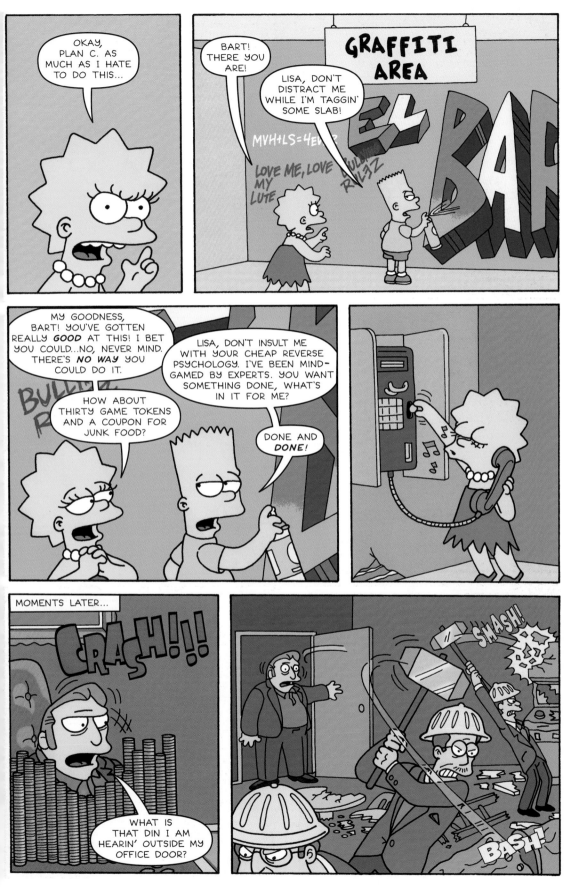

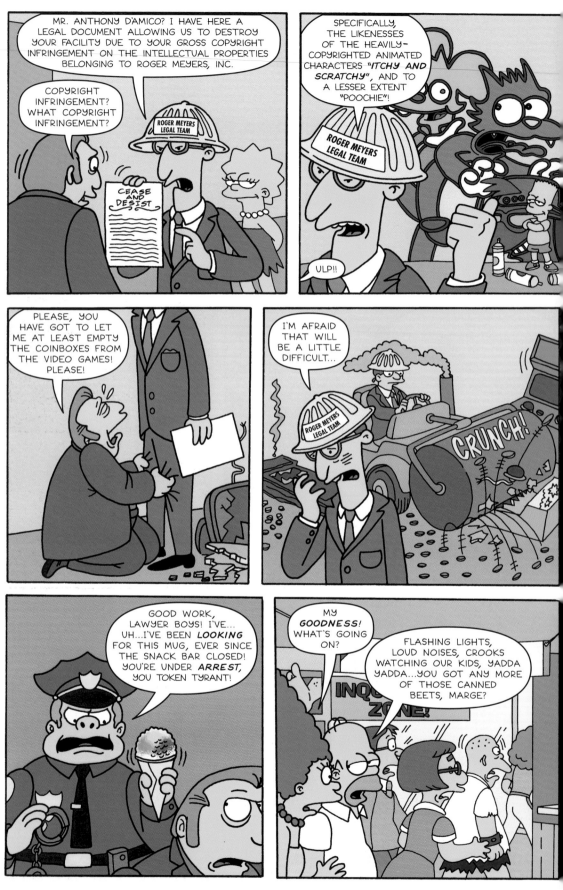

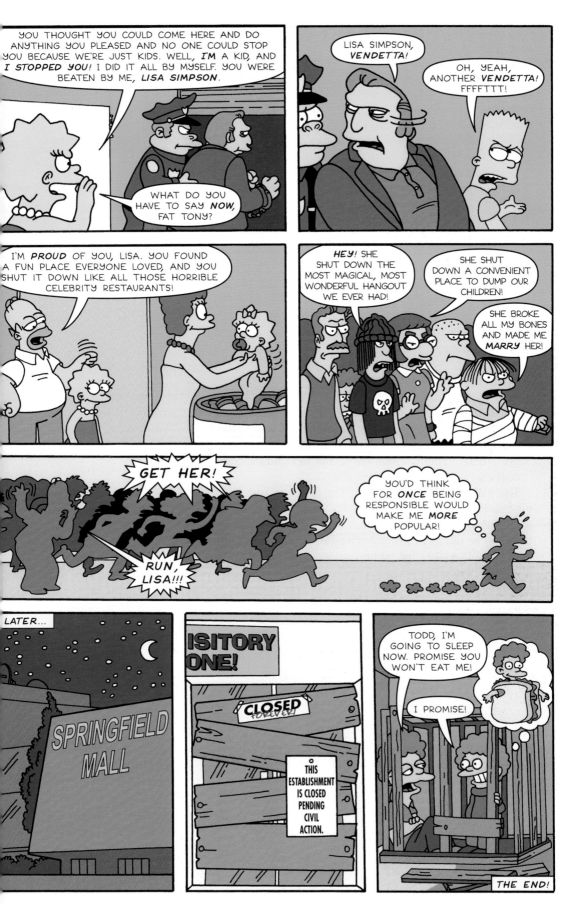

MY FIRST BULLY, PART ONE

It seems like yesterday.

I was seven years old, playing by myself in a vacant lot, as usual, creeping through the tall grass and trying to catch bugs. Suddenly, I caught a glimpse of a snake slithering away through the weeds, and in one leap I grabbed it. Oh man, it was a real wriggler, but I had my thumb and forefinger securely positioned right behind the head, so there was no way the snake could bite me. I held up the snake and admired it. I imagined how cool I must've looked at that moment.

"Betcha don't know how to hypnotize a snake," a voice said behind me.

I jerked around to see a spiky-haired kid with beady brown eyes standing on a tree stump, chewing gum. He was a little bigger than me, wore a buckskin jacket, and had a smudge of dirt across his cheek. I was impressed.

"You gotta rub the top of his head, and he'll go sleep," the kid said.

It sounded risky, but the kid was bigger than me, so I did it. Sure enough, after I stroked the snake's head, it seemed to calm down.

"Now you can let go of his head," the kid said.

"But he'll bite me," I said.

"Naw," said the kid. "He won't bite. He's hypnotized."

But I was chicken. I just stood there, holding the snake.

"Whatsamatter?" the kid sneered. "Ya chicken?"

"No," I said.

"Then prove it. Grab the snake by his tail."

I checked out the snake, and it did seem to be in a trance. So slowly, carefully, I grabbed the snake's tail with my free hand, and let go of its head with the other.

The snake immediately twisted up and bit me on the wrist. I yowled and dropped it, and the snake disappeared into the brush.

"You didn't hypnotize him right," the kid told me, yawning.

And that's how I met my new friend.

The kid's name was Franky Miller, and he'd just moved to Portland from Boise. He had a big black dog named Wolf and two scary teenage brothers, but during the three months he spent in the neighborhood, I never saw Franky's parents. He had no books and hardly any toys, but he did have a metal slingshot and a pickled frog in a jar.

I was both enthralled by and scared of Franky. He had this great scowl on his face at all times that made him seem superior to everyone our age. He was the first and only kid I ever knew who could actually hit things with his slingshot. And he came up with wild, surprising schemes, like the time he dared me to put my hand in a shoebox he was holding without looking. I did it, and got my fingers snapped by a mousetrap.

I started crying, so Franky put his arm around my shoulder.

"Hey, if I used a rat trap, you'd really be crying," he consoled me.

Franky was great at spotting bees' nests in trees, which we'd knock down with rocks and run away from. He had a vast selection of brightly colored cereals in his kitchen, which we'd chow down on every day after school. Franky was the only kid I knew who dumped sugar on cereal that was already sweetened. And when he wasn't tormenting me, he was quite entertaining.

One afternoon he came over to my house and walked in while I was reading a book about caves. Franky grabbed the book out of my hands and quickly leafed through it. Then he told me he'd been out in the forest the day before, and he'd discovered a cave! And not only that, the cave was huge! And not only that, way in the back of the cave was a pool of water, and the water was warm! You could swim in it! And not only that, there were fish in the pool! White fish! And the fish couldn't see, because they spent their whole lives in the cave! And the fish were tame, because they'd never seen humans before! And you could hold the fish in your hands! The fish didn't mind!

"Let's go there!" I said.

"No," Franky said. "Not yet. It's a secret."

"Aw, come on!"

"If you pass the test, then I'll show you."

"What's the test?"

Franky's eyes widened. "You'll find out," he said.

For the next few weeks, Franky told me more details about the cave, but he made no move toward taking me there, or even giving me the test. I found out that in some parts of the cave, you didn't need a flashlight, because the cave's walls glowed! And there was one part of the cave, way in the back, where there were these huge golden boulders.

"Gold!" I said.

"Maybe," said Franky.

So I waited impatiently, mulling over the details of Franky's cave. It sounded pretty far-fetched, even to a seven-year-old, but I desperately wanted the cave to be real, so most of the time I believed him, and when I got up the nerve to ask Franky a doubting question, he always had a good answer.

"If there's gold in the cave, why don't you show me some?" I asked.

"I tole ya," said Franky. "They're boulders. The boulders are too heavy to lift."

Finally one day Franky appeared at my bedroom door and whispered that it was time for me to take the test.

"And then you'll take me to the cave?" I asked.

"Sure," said Franky. "If you pass the test."

We walked over to Franky's house and I followed him into the garage, which was filled with boxes of empty pop bottles.

"First," said Franky, "we'll make a little atomic rocket juice."

He grabbed a dusty root beer bottle and poured the last few drips from it into a Coke bottle. Then he did the same thing with an old cream soda bottle, followed by a 7-Up bottle, an orange soda bottle, and so on.

"Don't just stand there," Franky said. "Start pourin'."

We spent the next half-hour pouring thick, heavy driplets from the hundreds of bottles in the garage into that single Coke bottle, until it was a little over half-full of filthy, disgusting, slimy liquid.

"I think that's about enough atomic rocket juice," Franky said, holding up the bottle and swishing it around.

Oh no! I suddenly realized. Franky's going to make me drink the atomic rocket juice! That's the test!

"This is the sweetest drink in the world," Franky said.

I got a weird feeling in my stomach.

"Wanna smell it?"

"No," I said.

"Go on," said Franky. "Smell it."

I sniffed. It smelled bad.

"Wanna drink it?"

"No," I said.

"Good," said Franky. "'Cause you ain't gettin' any."

And with that, Franky tilted the Coke bottle and swigged the whole liquid mess, gulping grotesquely. When he was finished, he wiped his mouth with his sleeve and burped.

I felt sick.

Franky looked at me.

"Now for the test," he said.

(To be continued . . .)

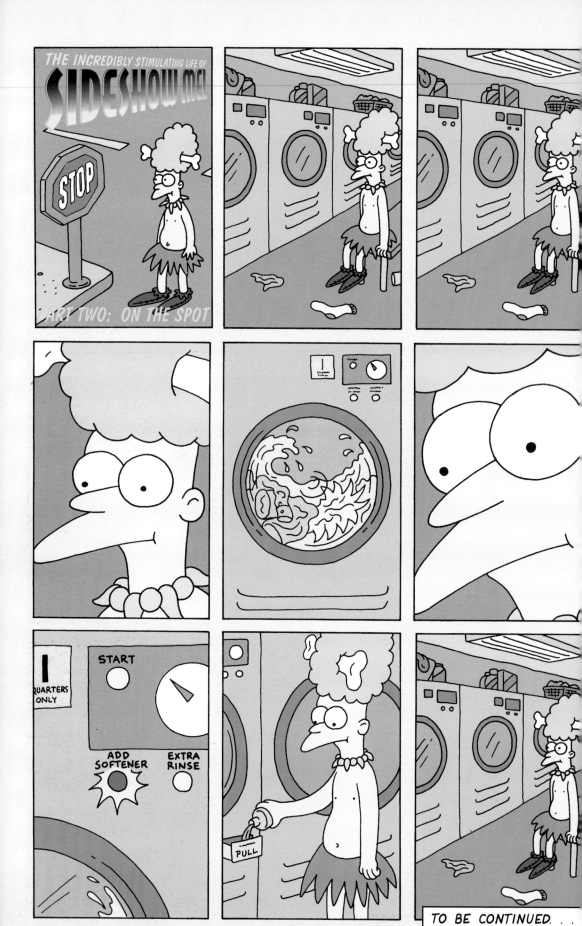

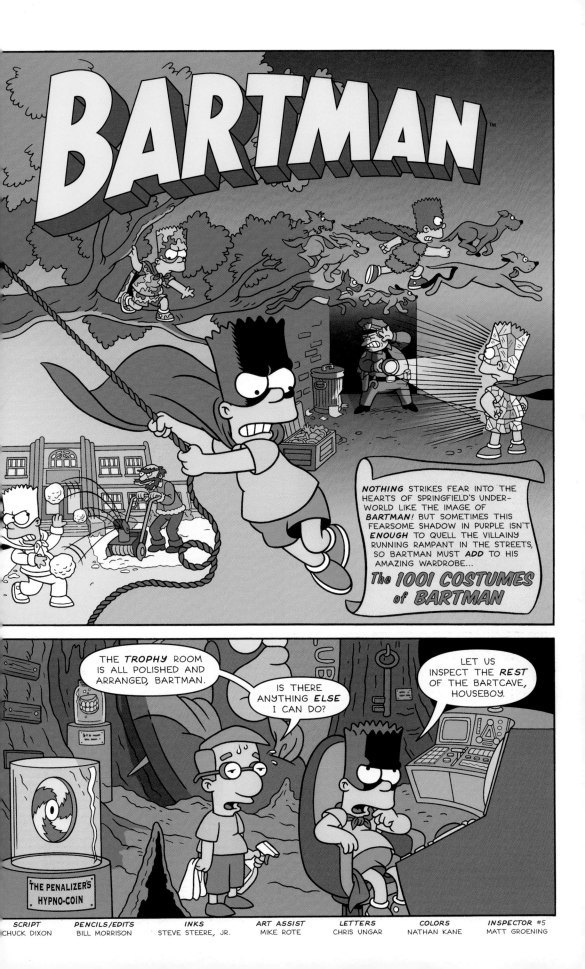

BARTMAN

NOTHING STRIKES FEAR INTO THE HEARTS OF SPRINGFIELD'S UNDER-WORLD LIKE THE IMAGE OF **BARTMAN!** BUT SOMETIMES THIS FEARSOME SHADOW IN PURPLE ISN'T **ENOUGH** TO QUELL THE VILLAINY RUNNING RAMPANT IN THE STREETS, SO BARTMAN MUST **ADD** TO HIS AMAZING WARDROBE...

The 1001 COSTUMES of BARTMAN

THE **TROPHY** ROOM IS ALL POLISHED AND ARRANGED, BARTMAN.

IS THERE ANYTHING **ELSE** I CAN DO?

LET US INSPECT THE **REST** OF THE BARTCAVE, HOUSEBOY.

THE PENALIZER'S HYPNO-COIN

SCRIPT — CHUCK DIXON PENCILS/EDITS — BILL MORRISON INKS — STEVE STEERE, JR. ART ASSIST — MIKE ROTE LETTERS — CHRIS UNGAR COLORS — NATHAN KANE INSPECTOR #5 — MATT GROENING

THE *BARTBOARD* IS OILED AND WAXED?

CHECK.

THE *BARTSIGNAL* IS OPERATIONAL?

LET ME SEE...

SCRATCHY

DING CARD

SERIES 1

OW!

CHECK.

KLIK!

THE *WARDROBE* IS LOOKING GRIM.

UM...CAN'T SEE...

ONLY HAVING ONE SPARE COSTUME *SUCKS*.

I CAN'T FIGHT CRIME UNLESS I LOOK MY *BEST*.

BEWARE EVILDOERS, OF... *BARTMAN!*

YOU MEAN *BARF*MAN!

HA, HA!

Vend-O

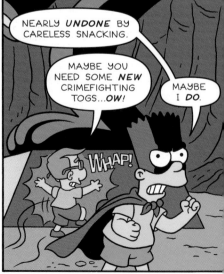

NEARLY *UNDONE* BY CARELESS SNACKING.

MAYBE YOU NEED SOME *NEW* CRIMEFIGHTING TOGS...*OW!*

MAYBE I *DO*.

WHAP!

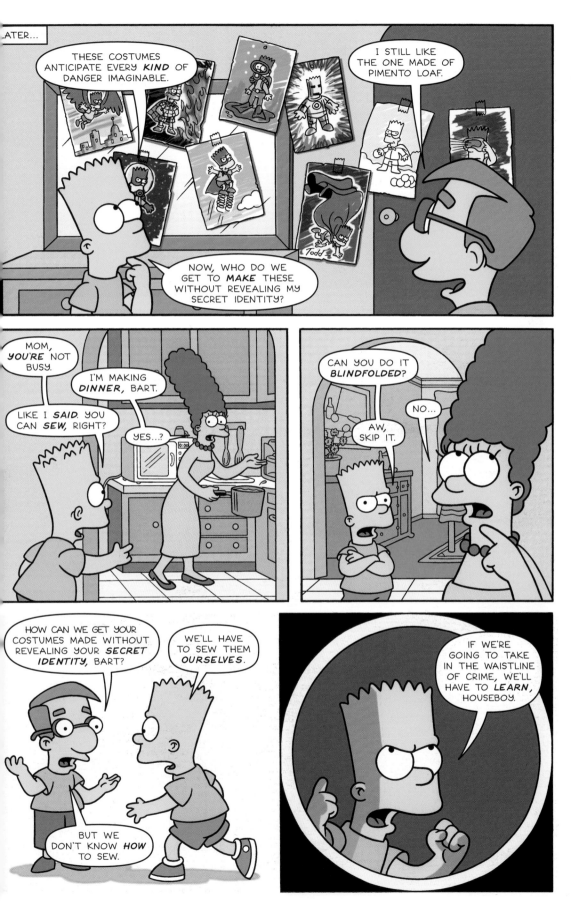

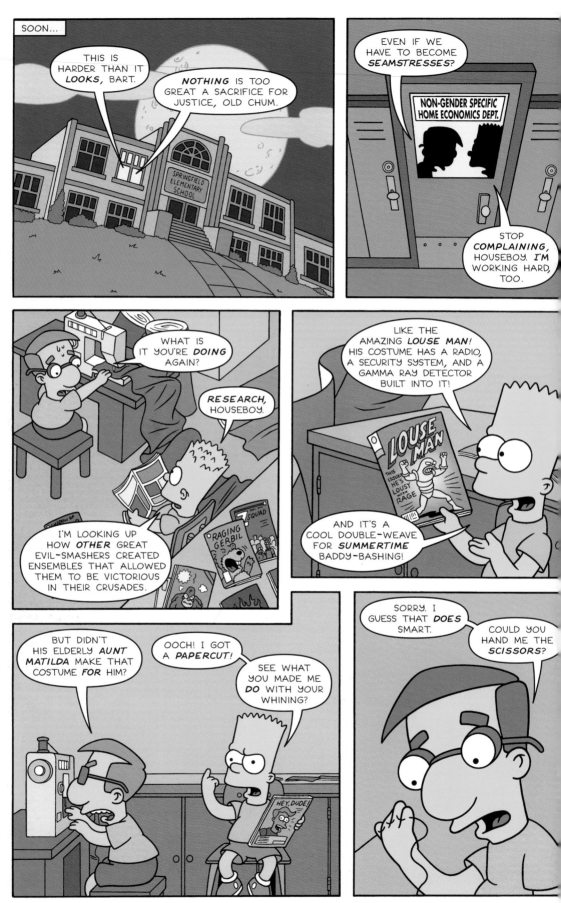

SOON...

THIS IS HARDER THAN IT **LOOKS**, BART.

NOTHING IS TOO GREAT A SACRIFICE FOR JUSTICE, OLD CHUM.

EVEN IF WE HAVE TO BECOME **SEAMSTRESSES**?

NON-GENDER SPECIFIC HOME ECONOMICS DEPT.

STOP **COMPLAINING**, HOUSEBOY. **I'M** WORKING HARD, TOO.

WHAT IS IT YOU'RE **DOING** AGAIN?

RESEARCH, HOUSEBOY.

I'M LOOKING UP HOW **OTHER** GREAT EVIL-SMASHERS CREATED ENSEMBLES THAT ALLOWED THEM TO BE VICTORIOUS IN THEIR CRUSADES.

RAGING GERBIL

THE SQUAD

LIKE THE AMAZING **LOUSE MAN**! HIS COSTUME HAS A RADIO, A SECURITY SYSTEM, AND A GAMMA RAY DETECTOR BUILT INTO IT!

LOUSE MAN

THIS ISSUE! HE'S LOUSY WITH RAGE

AND IT'S A COOL DOUBLE-WEAVE FOR **SUMMERTIME** BADDY-BASHING!

BUT DIDN'T HIS ELDERLY **AUNT MATILDA** MAKE THAT COSTUME **FOR** HIM?

OOCH! I GOT A **PAPERCUT**!

SEE WHAT YOU MADE ME **DO** WITH YOUR WHINING?

HEY, DUDE!

SORRY. I GUESS THAT **DOES** SMART.

COULD YOU HAND ME THE **SCISSORS**?

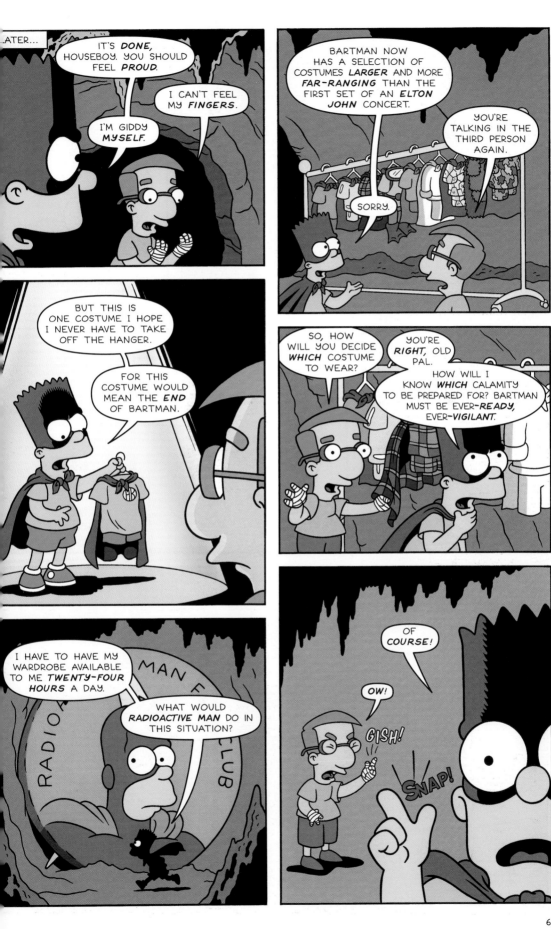

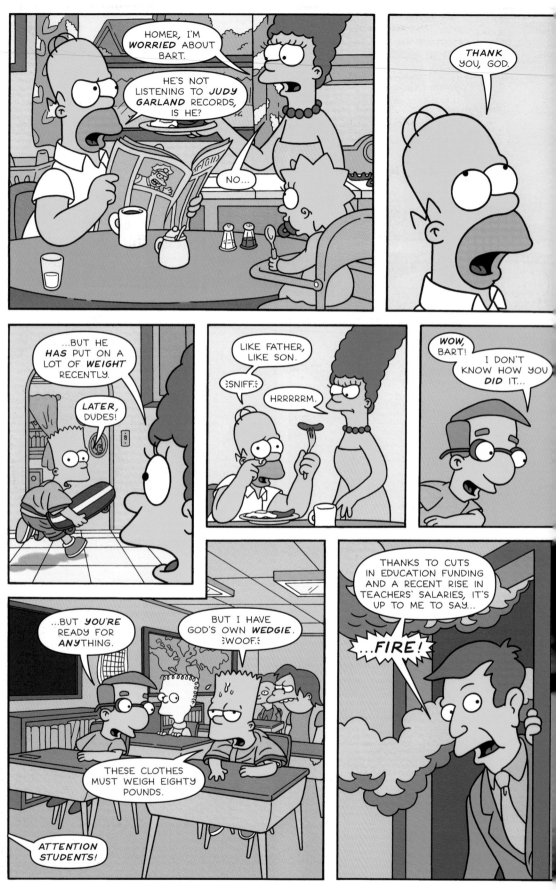

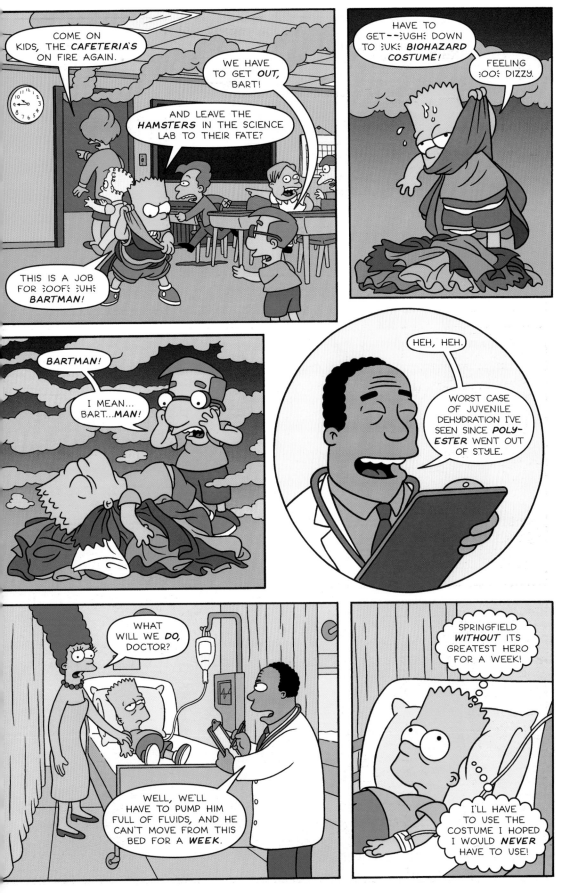

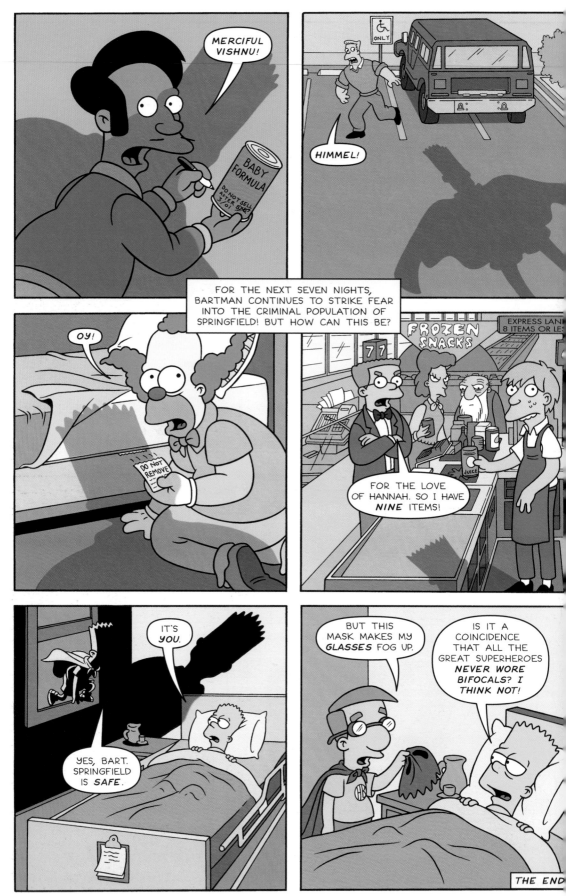

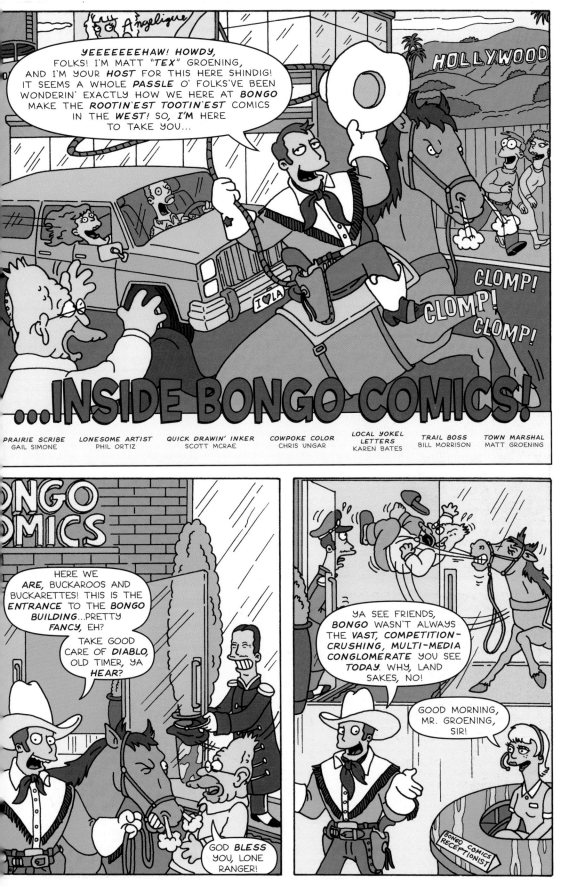

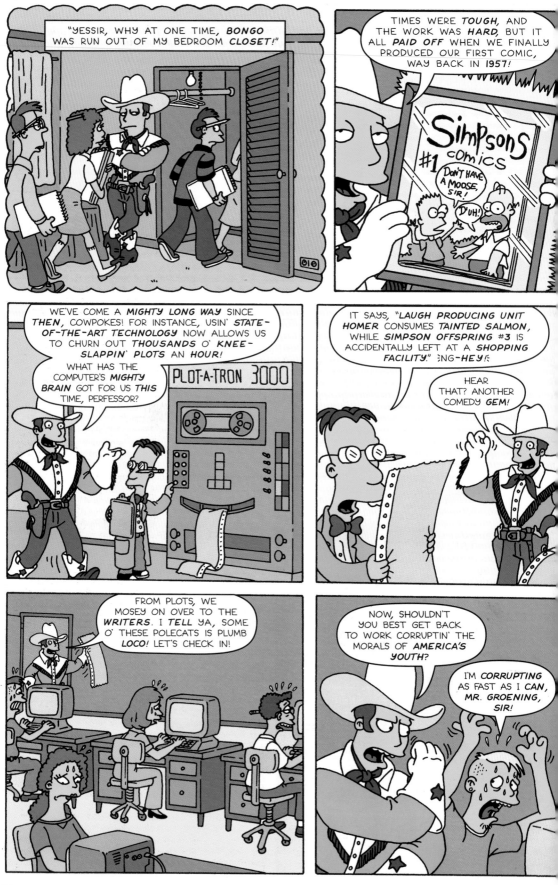

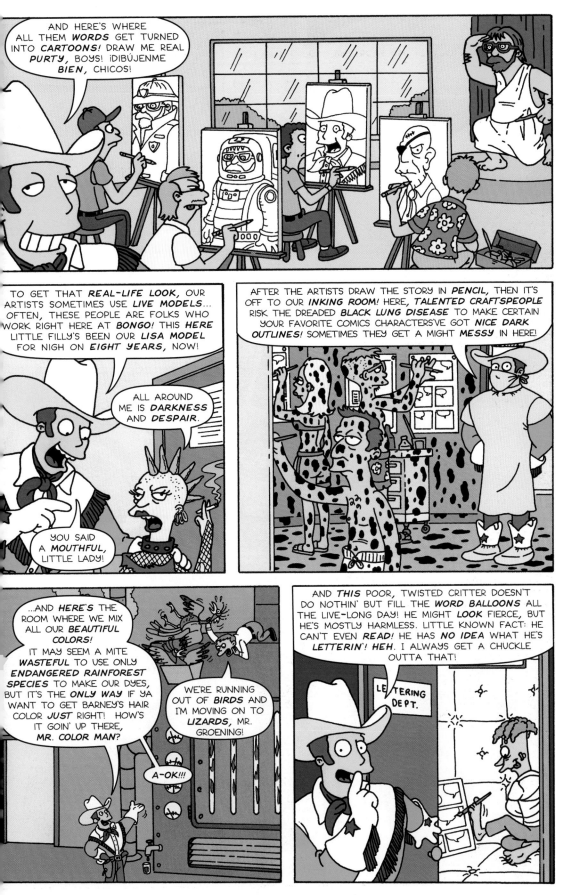

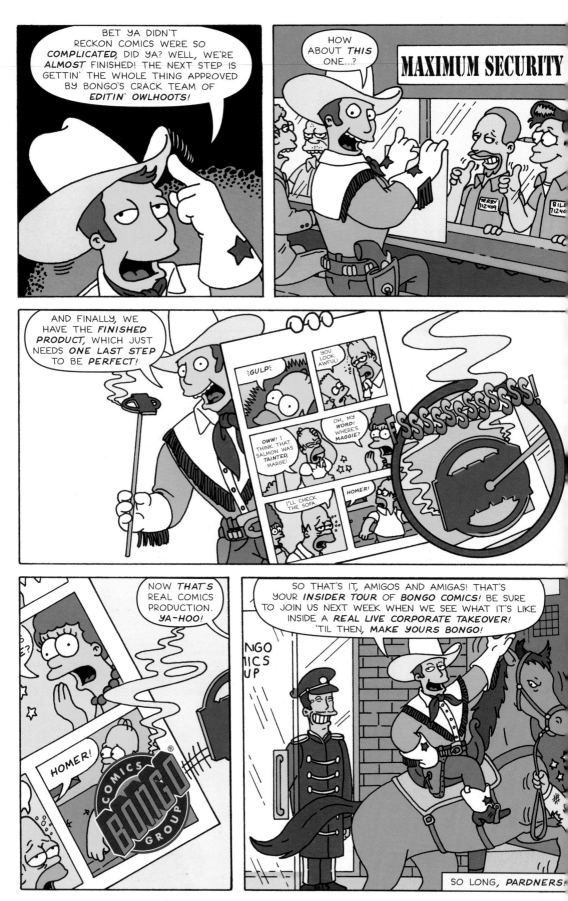

THE INCREDIBLY STIMULATING LIFE OF

SIDESHOW MEL

STOP

PART THREE: ON THE LAM

DEMOISTURIZER 3000

THE END

MY FIRST BULLY, PART TWO

The story so far: I was seven years old, and completely under the influence of a new kid in the neighborhood, Franky Miller. Everything about Franky impressed me: his big mean dog, Wolf; the way he said "warsh" instead of "wash" and "banure" instead of "manure"; his deadly aim with a slingshot; and most of all, his wild stories, which I didn't want to believe but which I did believe because I so desperately wanted the stories to be true. Franky really had me going with a story about his discovery of a secret cave in the woods, one with friendly albino fish and huge gold boulders. And he promised to take me there if I passed the test . . .

Franky led me out of the garage and into his backyard, then down a steep trail into the woods. We came to a clearing where a rope swing hung from a high tree branch, and Franky turned around and smiled.

"Wow!" I said. "Cool swing!"

"This here's your test," said Franky. "Get on the swing."

I sat down and Franky started to twirl me around slowly, winding the swing's ropes around each other. "I'm gonna wind you up a-hunnerd times," he explained, "and let you spin around till you stop. If you can do that, you pass the test."

I got scared. This was going to make me awful dizzy, I suddenly realized.

Franky kept twirling me slowly, winding me up.

"You promise you'll take me to the cave?" I said.

"Cross my heart and hope to die."

"Stick a needle in your eye?" I asked.

"Yep."

"Okay then," I said, satisfied.

It took him a long time to spin the swing around a hundred times, but finally Franky was finished. He held on to my feet, which were stuck out straight, and asked, "Are you ready?"

"Ready," I said.

"Are you set?"

"Set," I said.

"Then so long, sucker!" Franky squealed, giving my legs a vicious spin.

Everything was suddenly extremely blurry—the tension in the intertwined ropes made me spin like crazy—and I shut my eyes as my brain seemed to wobble and twirl inside my head. Oh man, this was bad.

Hang on, hang on.

I had to hang on.

I was going around much faster than seemed possible, and in the midst of my whirling torment, I could hear voices shouting encouragement.

Who was there besides Franky?

Whirling.

What's happening to me?

Swirling.

This was horrible.

"Go, man, go!" I heard someone shout.

It sounded like Franky's teenage brothers were there! Maybe they would save me!

"Help!" I yelled. "Help!"

But Franky's brothers didn't help.

In fact, they seemed to be laughing their butts off.

I started feeling sick, and right about the moment that I seriously began to consider the possibility that I might throw up, I began throwing up. And when I say throwing up, I don't mean small, easily handled gushes of vomit—I'm talking about long, gooey, stringy, flingy, corn-laden, throat-stingy wallops of puke—I mean, puke that just kept on a-comin'—puke torpedoes—till there couldn't be any liquid left inside me—and still I kept spewing.

Then I lost my grip on the ropes and hit the ground with a thud. I was no longer moving, but the world kept spinning. I could do nothing except lie there, moaning.

A few minutes later, I struggled to my feet and looked around.

I was alone.

After that, I didn't hang out with Franky too much. He shunned me most of the time, and went around telling everybody at school what a baby I was because I'd "ralphed" (his word) on a swing. I hated the word "ralph"—it sounded so shameful. I suppose my friend Ralph hated it even more.

Then I started hating Franky's guts, especially since I realized that his secret cave was probably a big fib.

I had just two further run-ins with Franky. One sunny, Sunday afternoon he rode his bike down my street, Evergreen Terrace, and yelled in his old, friendly way for me to follow him.

"You gotta see something really cool!" Franky said.

I ran down the street after him, and he led me to Mrs. Gates's house a couple blocks away. Franky nonchalantly let his bike fall over onto Mrs. Gates's flowers, then he started to look around to make sure we weren't being watched.

"Follow me," he whispered, sneaking into Mrs. Gates's garage.

Franky pointed to the shadows. I squinted. In the back of the garage was a row of shelves lined with tiny ceramic dogs.

"Treasure," whispered Franky.

"These are cool dogs," I whispered back.

"Let's steal 'em," whispered Franky.

I won't go into the moral quandary I felt at that moment, but I did feel a moral quandary, and it did last a moment.

I picked up a shiny dachshund, which I liked, because it reminded me of Mrs. Gates's real dachshund Sparkle. Meanwhile, Franky was stuffing his pockets with dogs.

Suddenly, we heard Mrs. Gates's front door open.

Franky's eyes widened.

"Run!" he yelled.

I stood there like a fool, watching Franky dash out of the garage, his pockets bulging. He jumped on his bike and sped down the hill. I started to walk out with the little ceramic dachshund cupped in my hand.

"What have you got there?" I heard Mrs. Gates call from her front porch.

"A grasshopper," I said.

I kept on walking. I could see Franky a block away, peeking out from behind some bushes next to the woods.

"Let me see it," said Mrs. Gates.

"I can't," I replied, walking a little faster. "If I open my hands, he'll get away."

I felt awful. I liked Mrs. Gates, I liked her dachshund, I liked her little dog figurines, and now I was stealing from her, and lying about it.

I broke into a run.

When I got to the woods, I took off after Franky down a long, narrow path through the trees, ferns, and rotten logs along a steep ravine. Finally we stopped and hid behind a large pine tree.

"That was a close one," he said, panting.

"Yeah," I puffed in agreement.

Franky dumped out his dogs on the ground, and I placed mine in the pile. We admired the dogs for a minute or two.

"You better go back up the trail and see if the old lady is following us," Franky suddenly said.

I did as I was told. When I stuck my head out of the bushes at the edge of the woods, the street was deserted. I raced back down the trail.

"All clear," I reported.

Franky was standing there holding a big rock in both hands.

"We gotta destroy the evidence," he said.

And with that, Franky raised the rock above his head and threw it down, smashing the little dogs to pieces.

And that's when it hit me: Franky was nuts.

"Let's get out of here," he said, and we did.

The next day, on the crowded city-bus to school, Franky and I just stood there and looked at each other warily. I felt tense and guilty. I had nothing to say to Franky.

Just before we got to school, the bus driver put on the brakes a little too hard, and a girl I was standing next to bumped into me.

"You gonna let a little girl push you around?" Franky sneered loudly, so everyone could hear. They all looked.

"No," I said.

"You're such a baby you're afraid of a little girl," he taunted.

"No I'm not," I said.

"Then why don't you push her back?" he said.

"I don't feel like it," I said.

"If you ain't afraid, then I dare you to push her," said Franky.

So I gave the girl a little shove, and said to Franky, "Now are you happy?"

I had barely finished my sentence when Franky yelled, "You hit a girl!"

"I didn't hit her," I explained. "I just—"

"Nobody hits a girl!" Franky snarled.

And he smashed me in the face with his fist. And I went down, blubbering.

In the principal's office, I sat there glumly. It was the first time I'd been sent there for getting into trouble (but not the last). Franky just stared at me, his eyes bulging with some sort of spooky significance. I was afraid that Franky would tell about stealing the ceramic dogs, and even more afraid that Franky would get some sort of diabolical revenge on me later, so I didn't squeal. The principal, no doubt puzzled, finally sent us back to our classes.

And that was the end of my friendship with Franky.

I managed to avoid him for the next couple of months, and then he and his family suddenly packed up and moved to Alaska. I was relieved.

With Franky gone, I felt free and happy. Well, a little.

I still felt ashamed for ralphing. And for stealing. And for shoving the little girl.

I wanted to tell Mrs. Gates I was sorry about her little dogs, but I felt too guilty to confess. I did go back down the trail to bury the ceramic dog pieces, but they were gone. I got a pocket knife and tried to cut the rope on that creepy swing, but the blade was too dull to do much damage, and I finally gave up.

And I still think about that secret cave with the gold and the albino fish sometimes.

EVERYTHING I KNOW ABOUT LIFE

Be bold and courageous. When you look back on your life, you'll regret the things you didn't do more than the ones you did. This advice does not apply to throwing rocks at hornets' nests.

When the sign says HIGH VOLTAGE, you better believe it.

In Zen, the first awareness is that nothing in the world is permanent (except perhaps a red-wine stain on a white silk shirt).

Don't eat meals at convention centers.

Beware of any entertainment experience described as "zany."

Most garage sales are really depressing.

Watch out for anyone who calls himself "Uncle" who's not your uncle.

Time is money, unfortunately.

Life is too short to watch reruns (except for *The Simpsons*, of course).

Playing solitaire is its own punishment.

When an old duffer at a family reunion uses such colorful folksy phrases as "slicker'n snot on a doorknob," beware—he could very well start doing magic tricks with coins at any second.

Go for the gusto, except when it comes to beer.

Run—don't walk—from all open-mike poetry readings.

Just because they add wacky sound effects on *America's Funniest Home Videos* doesn't mean that the people in those videos don't get injured.

In the entire history of popular music, there has never been a listenable demo cassette of an unsigned band.

Another thing that sets humankind apart from animals: Humans are the only creatures who eat corndogs voluntarily.

Don't follow advice you get from comic books.

People say "Outrageous!" when they really mean "That's mildly interesting."

Contrary to popular belief, honking your horn in a traffic jam does not make the cars move faster.

Never look inside a Big Mac just before you eat it.

The love you take is equal to the love you make, plus postage and handling fees.

Beware of all enterprises that require you to wear a chicken costume and stand on the street, waving wildly at passing motorists.

When people say, "Be careful what you wish for—you may get it," reply, "I wish you'd shut your big fat mouth."

Before you get that tattoo of Hootie and
the Blowfish on your bicep, think very,
very carefully.

Tomorrow is the day after the first
day of the rest of your life.

Beware of men with tassels on their
loafers.

Just do it.

If that doesn't do it, just undo it.

Stalk your bliss.

UNCLE
MATT

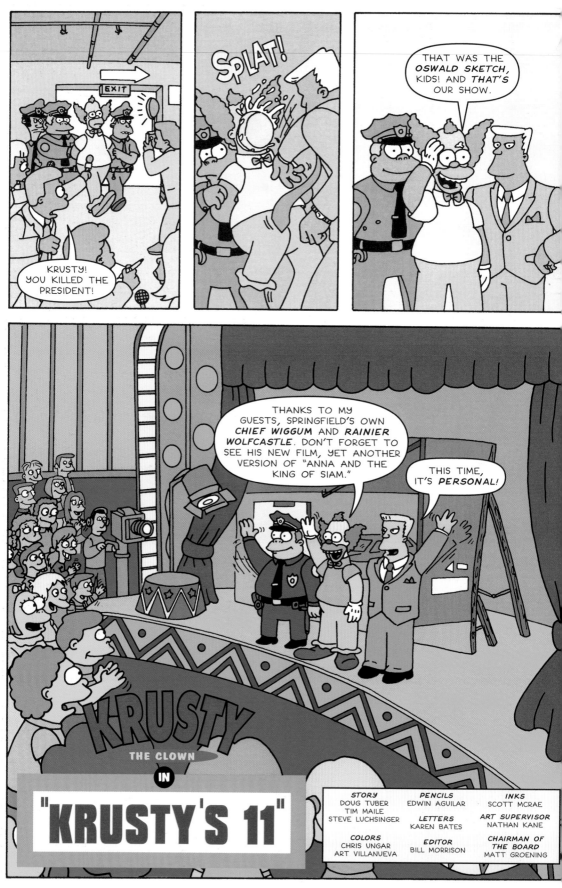

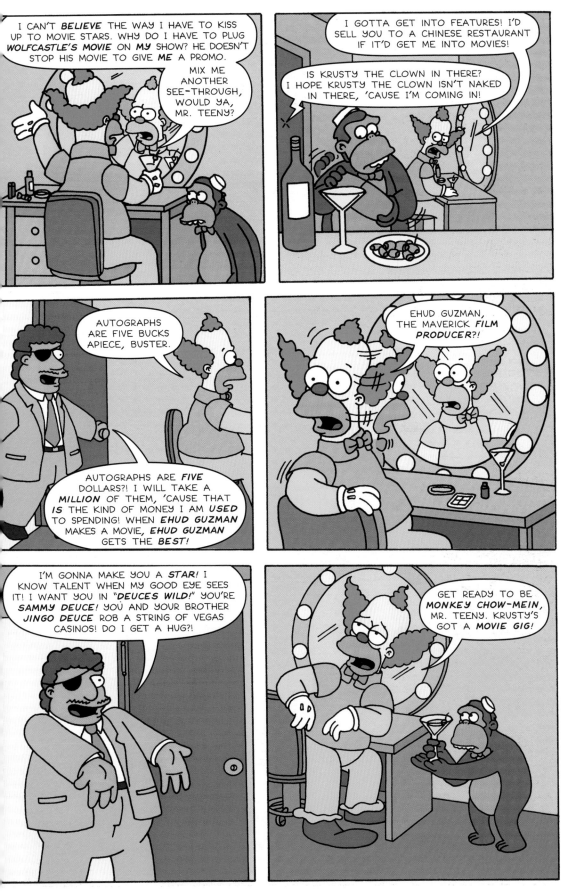

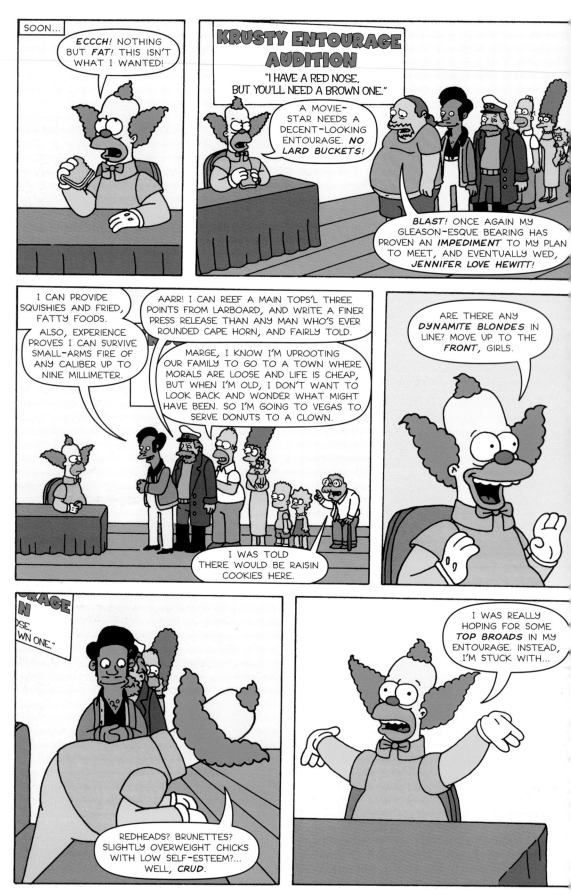

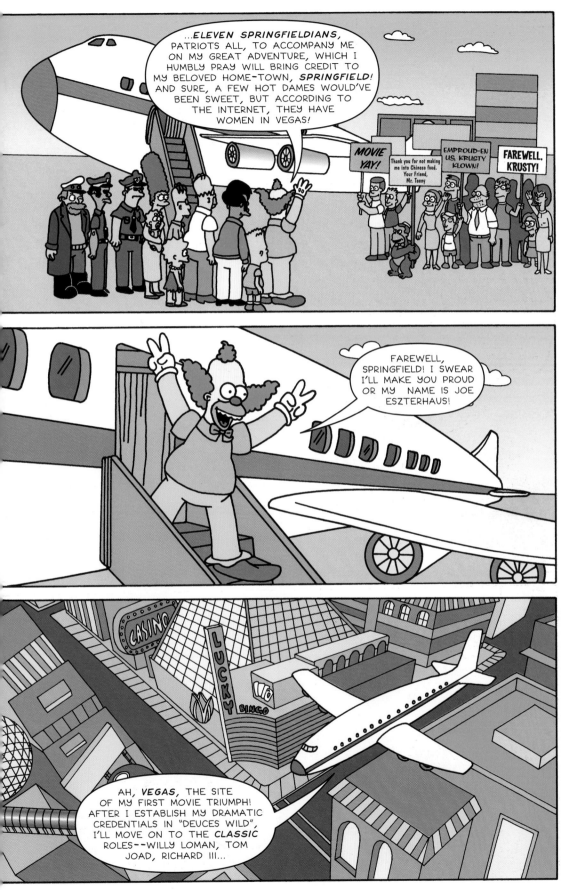

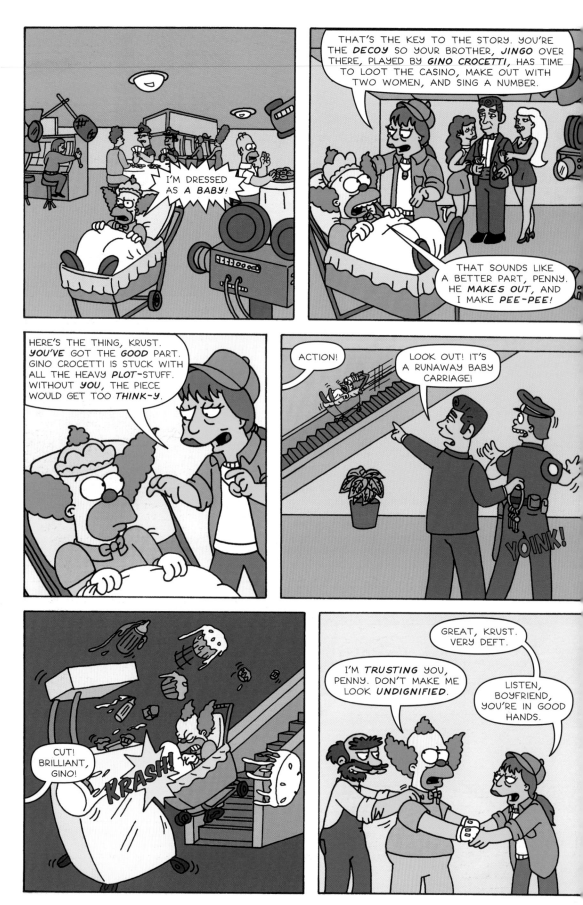

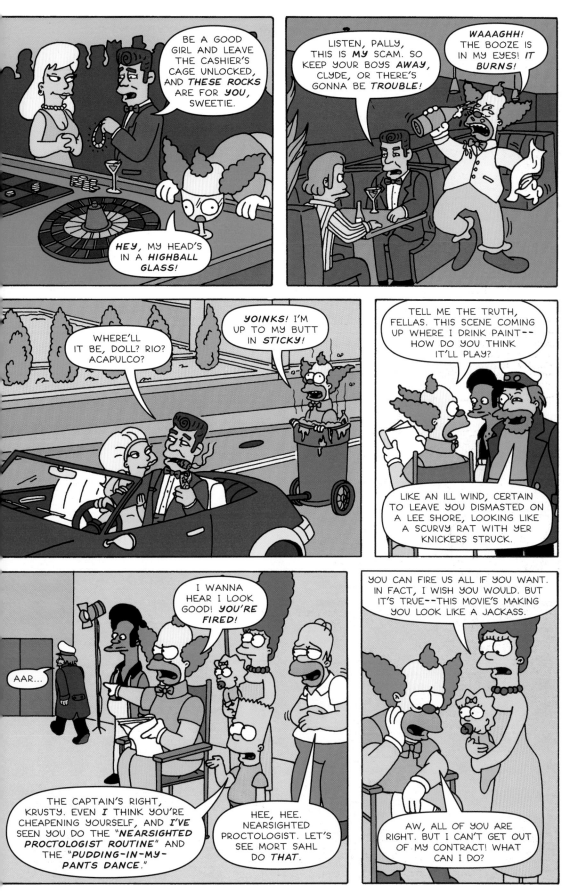

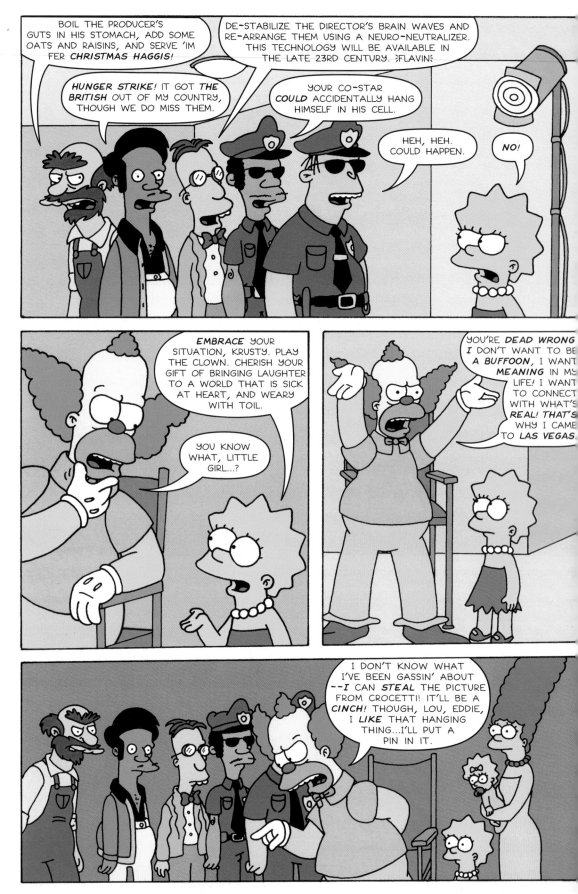

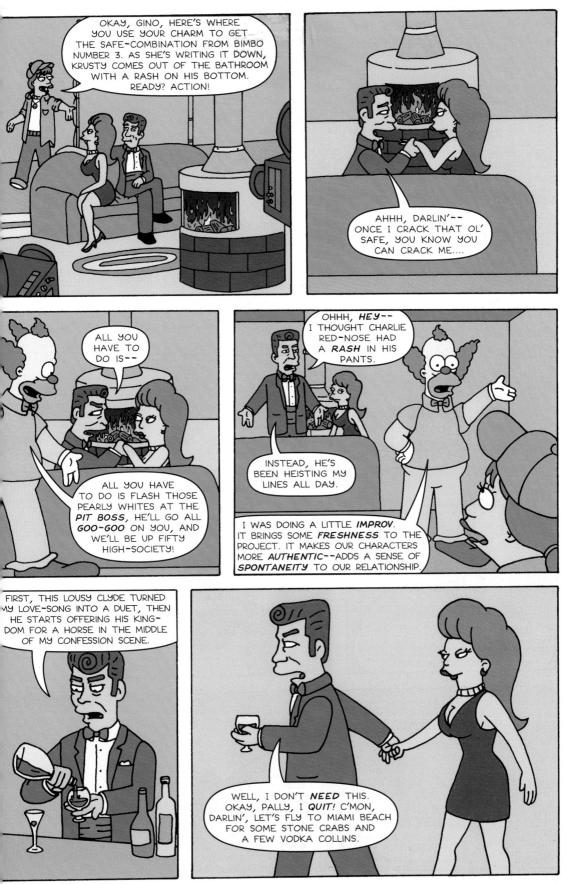

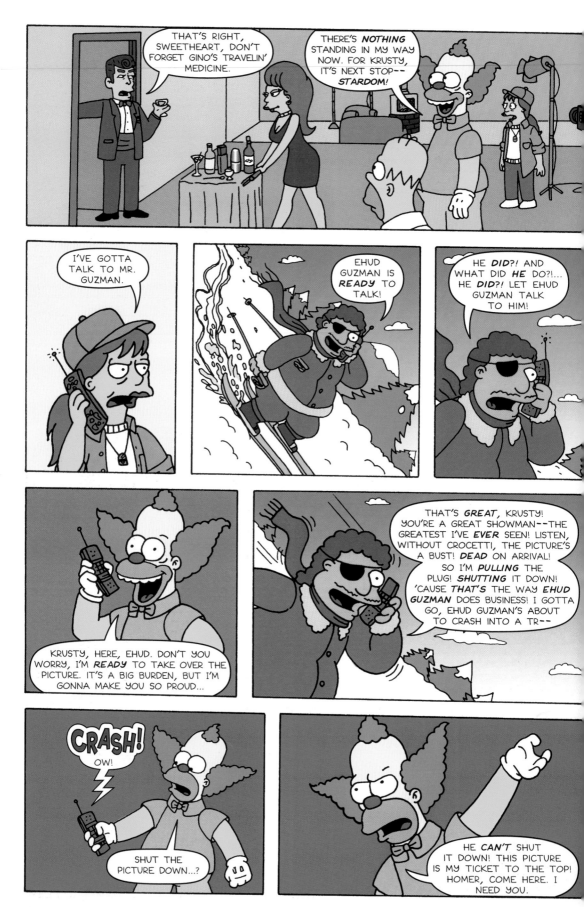

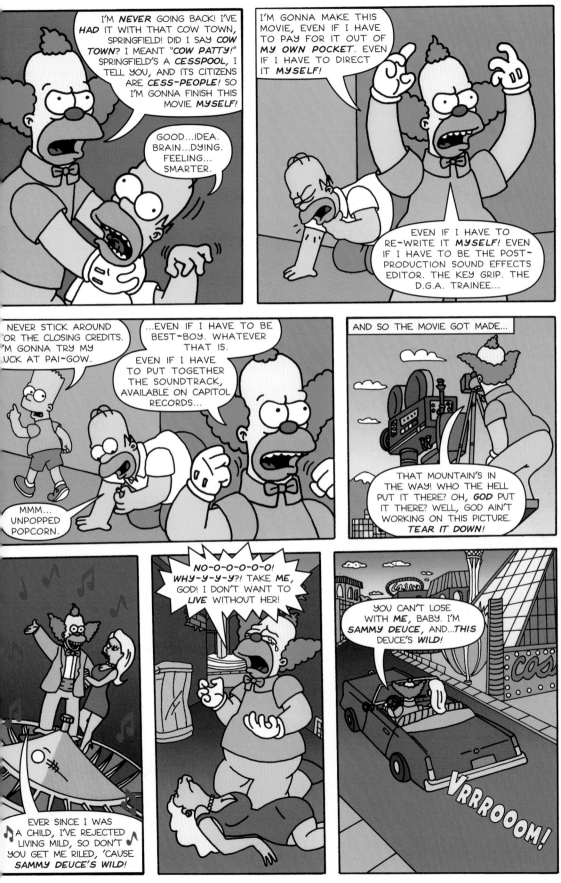

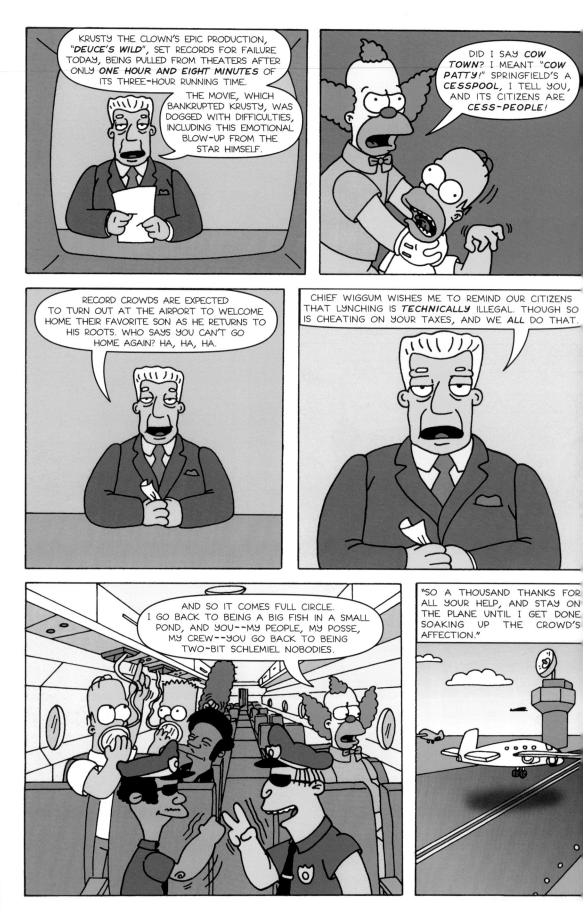

KRUSTY THE CLOWN'S EPIC PRODUCTION, *"DEUCE'S WILD"*, SET RECORDS FOR FAILURE TODAY, BEING PULLED FROM THEATERS AFTER ONLY *ONE HOUR AND EIGHT MINUTES* OF ITS THREE-HOUR RUNNING TIME.

THE MOVIE, WHICH BANKRUPTED KRUSTY, WAS DOGGED WITH DIFFICULTIES, INCLUDING THIS EMOTIONAL BLOW-UP FROM THE STAR HIMSELF.

DID I SAY *COW TOWN*? I MEANT *"COW PATTY!"* SPRINGFIELD'S A *CESSPOOL*, I TELL YOU, AND ITS CITIZENS ARE *CESS-PEOPLE!*

RECORD CROWDS ARE EXPECTED TO TURN OUT AT THE AIRPORT TO WELCOME HOME THEIR FAVORITE SON AS HE RETURNS TO HIS ROOTS. WHO SAYS YOU CAN'T GO HOME AGAIN? HA, HA, HA.

CHIEF WIGGUM WISHES ME TO REMIND OUR CITIZENS THAT LYNCHING IS *TECHNICALLY* ILLEGAL. THOUGH SO IS CHEATING ON YOUR TAXES, AND WE *ALL* DO THAT.

AND SO IT COMES FULL CIRCLE. I GO BACK TO BEING A BIG FISH IN A SMALL POND, AND YOU--MY PEOPLE, MY POSSE, MY CREW--YOU GO BACK TO BEING TWO-BIT SCHLEMIEL NOBODIES.

"SO A THOUSAND THANKS FOR ALL YOUR HELP, AND STAY ON THE PLANE UNTIL I GET DONE SOAKING UP THE CROWD'S AFFECTION."

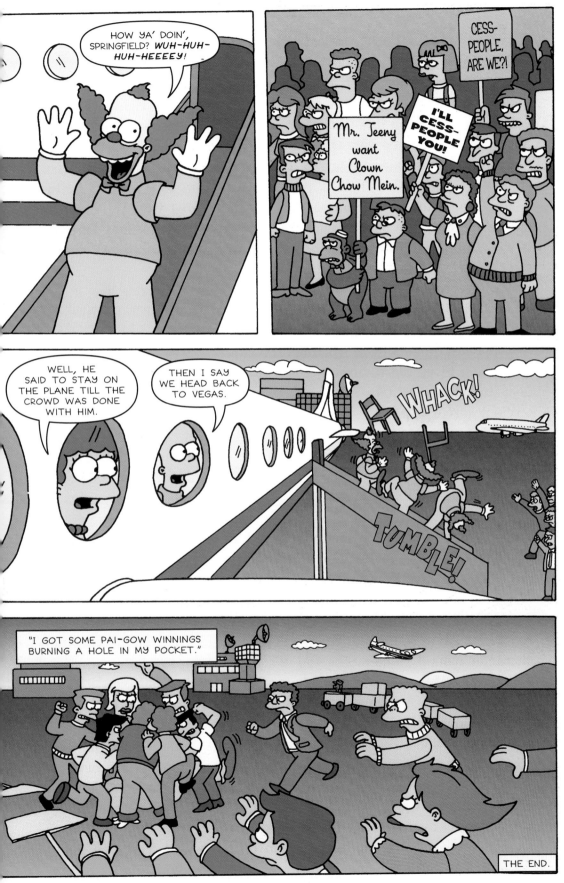

47 SECRETS ABOUT *THE SIMPSONS,* A POEM OF SORTS, AND SOME FILLER

1. Bart Simpson's middle name is Jo-Jo. 2. My sixth favorite Itchy & Scratchy cartoon is *The Discreet Charm of the Rotisserie.* 3. Bart got his middle name at a recording session, when Nancy Cartwright (who does the voice of Bart) had a line that went, ". . . or my name isn't Bartholomew J. Simpson." I asked her what the J. stood for, and she said "Jo-Jo." 4. Homer J. Simpson's middle name is "Jay." 5. The rest of the family's middle names also start with the letter J. 6. This "J" business is a tribute to Jay Ward's Bullwinkle J. Moose and Rocket J. Squirrel. 7. I don't remember what the other middle names are. 8. Marge Simpson has webbed toes. 9. Homer Simpson's favorite movie is not *Look Who's Oinking,* as is commonly believed, but *Look Who's Oinking III.*

10. Evergreen Terrace, the street on which the Simpsons live, is also the street I lived on as a kid in Portland, Oregon. 11. My fifth favorite Itchy & Scratchy cartoon is *20,000 Shrieks Under the Sea.* 12. Homer loves any chore that involves the licking of frosting off beaters.

13. Apu loves the luxuriant, silky feel of pure polyester. 14. My fourth favorite Itchy & Scratchy cartoon is *The Blast of the Mousehicans.* 15. In the original design of Homer, I hid my initials in his head. 16. The M was the zigzag hair above Homer's ear, and I drew his right ear as a G. 17. I decided that if this secret ever got out, it would be too distracting, so I changed his ear to look more like a regular cartoon ear. 18. When I draw sketches of Homer for fans, I put in the secret initials.

19. Bart Simpson's number-one pet peeve: Lisa's slumber parties. 20. When correctly drawn, Bart has nine points of hair on his head. 21. When Homer says "D'oh!" on the show, it is written in the scripts like this: (ANNOYED GRUNT). 22. When Marge makes that displeased-Marge noise on the show, it is written in the scripts like this: (FRUSTRATED MURMUR).

23. My third favorite Itchy & Scratchy cartoon is *Romeo and Thumb-screwliet.* 24. In Nathanael West's classic novel *Day of the Locust,* there's a character named Homer Simpson. 25. Marge Simpson hates waxy yellow build-up. 26. Milhouse was named after Richard Milhous Nixon. 27. I drew a cartoon character in high school named Milhouse Mouse. 28. In grade school I drew, among other things, cartoon slugs.

29. There are streets in Portland, Oregon, named Flanders, Kearney, Lovejoy, and Quimby. 30. Apu was named after the character Apu in Satyajit Ray's *Pather Panchali* (one of my all-time favorite movies). 31. My mother's maiden name is Wiggum. 32. As far as I know, Homer's power plant coworker Lenny doesn't have a last name.

33. Sideshow Bob's real name is Bob Terwilliger. 34. There's a Terwilliger Boulevard in Portland, Oregon. 35. My second favorite Itchy & Scratchy

cartoon is *Scratchy, I Shrunk Your Kidneys*.

36. Sideshow Bob's prison number is #24601. 37. My favorite minor characters on the show include Jasper, Hans Moleman, Bumblebee Man, Jimbo, and the Ol' Sea Captain. 38. There was once a Krusty the Clown spin-off TV show in the works. Don't hold your breath.

39. Utterly non-Simpsons-related book recommendation: Eric Knight's *You Play the Red and the Black Comes Up*. 40. I write poetry occasionally. 41. On February 27, 1992, I wrote a poem called "Bossy Blues." 42. It was inspired by misunderstanding the lyrics of a Mississippi John Hurt song I heard on the radio while driving to work. 43. It goes like this: I woke up this morning/With a cow tied 'round my head/I woke up this morning/With a cow tied 'round my head/I wanted to get some breakfast/But the spoons were in the shed.

44. My favorite Itchy & Scratchy cartoon is a toss-up between *The Unbearable Lightness of Fricaseeing* and *You're a Good Corpse, Scratchy Brown*. 45. The original title of this editorial was WHY BART'S HAIR IS SO SPIKY: A CARTOONIST'S CONFESSION, but I was too tired to write it, so I did this list instead.

46. You want to know a word that I like that repels me at the same time?

47. Snausages.

Your pal,

MATT

MY ROCK 'N' ROLL LIFE, PART ONE:
SO YOU WANT TO SNORT DERISIVELY

In a former, pre-cartoonist, parallel-universe life, I used to be a rock critic of sorts. I say "of sorts" because any real rock critic would snort derisively at my so-called rock criticism—and, of course, they often did. It wasn't until later that I realized that rock critics become rock critics just to have an excuse to snort derisively. I know that was my reason.

Back in 1982, the editor of the *Los Angeles Reader*, a free newspaper where I did a little editing and paste-up, gave me my own weekly column, which was supposed to be about rock 'n' roll, but rarely was, because my 1962 Dodge Dart would usually break down on the way to the nightclub, and instead of reviewing a gig by Grumpy's Wooden Leg, the Yodelinos, or Mule Nostril (all real names), I'd write about what it was like to change a tire at midnight on Sunset Boulevard while dodging beer cans being flung at my head by troubled but carefree teenagers.

The newspaper editor kept complaining that there wasn't enough rock 'n' roll in my rock 'n' roll column, and I could do nothing but hang my head in shame. And then snort derisively when he wasn't looking.

I had to admit, the editor was right—there wasn't much rock 'n' roll in my column—but I couldn't bring myself to actually write about rock 'n' roll, because reviewing different rock bands felt the same as getting worked up about the merits of various breakfast cereals.

Are Lucky Charms *really* all that magically delicious? What's the deal with Count Chocula? And how do Snap and Crackle feel about Pop's new solo album?

I was miserable. I stayed up until 4 every night carousing in clubs and sleeping till 2 p.m.; I was so miserable. I was pretty cranky every time my weekly deadline rolled around, and I'd spend hours staring at my tiny pale green Hermes 3000 portable typewriter. Eventually I'd get out of bed and write the damn column.

What I did was make up stuff. I created fictional bands that played in nonexistent clubs and gave fake reviews to fabricated records, and no one was the wiser, or maybe no one bothered to read my column. When I was stuck for space, I'd invent long lists of bands—the Frinkles, the Corn Syrup Experience, Gimme That Chew Toy, etc.—and then add a parenthetical remark that these were all real names (see second paragraph of this column). The following week I'd confess that I'd made everything up in the previous column, then I'd swear that everything in the new column was true.

Then I'd make up a whole bunch of other stuff and snort, not so much derisively as gleefully.

This troubled but carefree life went on for weeks and weeks, until I was fired.

I gasped in shock. I sputtered in indignation. I stewed in my own juices.

I got what I deserved.

But secretly I was exuberant to be rid of the job, even though this meant

I'd have to scramble more than usual to make the monthly rent for my seedy Hollywood apartment.

At least rock 'n' roll is out of my life forever, I thought.

Little did I know that one hot spring evening in the near future I'd be onstage at the Hollywood Palladium, screeching the chorus of "Gloria" in front of a thousand people, gyrating lasciviously in a fez and bootleg Simpsons T-shirt, twirling, bellowing, and lumbering about like Barney the dinosaur on heroin, and strangely feeling no shame.

How did I sink so low in ten short years?

(To be continued . . .)

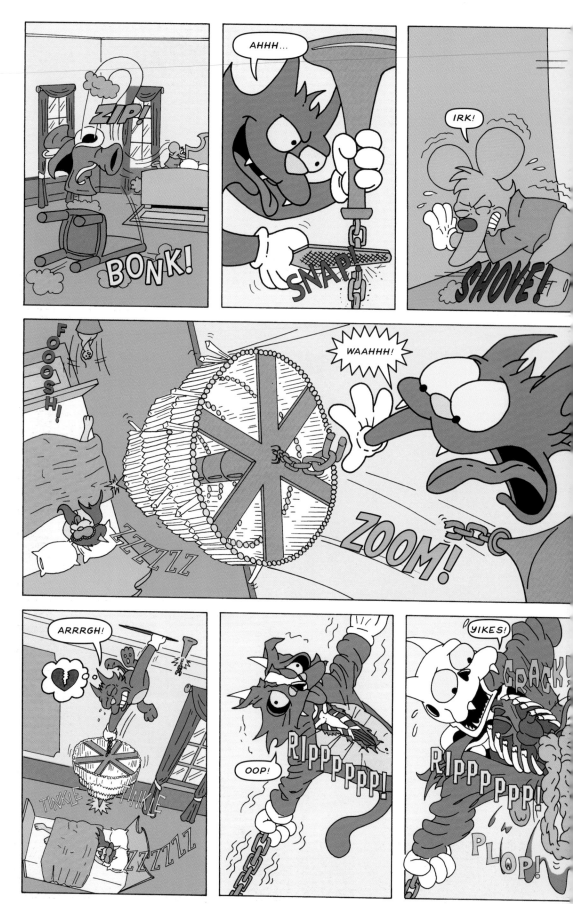

MY ROCK 'N' ROLL LIFE, PART TWO: THE UTTER SHAME OF UTTER SHAMELESSNESS

In our last installment, I confessed my tawdry past as a feisty rock critic. Those were the bad old days, when I spent countless hours in dank Hollywood dungeons pretending to groove to snarly little punk trios with names like the Fabulous Drippies, My Head Itches, and Pass the Sewage. But it slowly dawned on me that there was no future in No Future, so one hot night circa July, 1985, I took off my rock critic uniform (black T-shirt, black Levis, black tennis shoes, black circles under my eyes) for the last time and said, *Goodbye to all this jive.*

Around this time I stumbled onto a clever cartooning scam, where newspapers would pay me a few dollars here and there to print my crude, comic-strip-style doodles. In tribute to my vaguely punkish rock-critic life, I called my cartoon "Life in Hell," which I almost immediately regretted, but which I figured I was stuck with. (It's bad enough that the name no longer amuses me, but nobody even gets it right—everyone calls it "Life Is Hell.") And because I didn't have to listen to rock 'n' roll anymore, I started listening to other kinds of music—alpenhorn, jug band, yodeling, musical saw, and so on—and I figured out, that as good as rock 'n' roll is, all these other kinds of music are even better, and they're sung and played by people with slightly less stupid hairstyles.

A few years passed, and I thought up this other scam—you know it as *The Simpsons*—and before I knew it, I found myself a bona fide cartoon-book author (*Love Is Hell*, etc., etc.), and thus eligible to be in this all-author rock 'n' roll band that Kathi Goldmark, the San Francisco singer and authors' escort, dreamed up. Now, I had put rock 'n' roll behind me forever, but you have to understand—this was my big chance! My big chance to reaffirm my love of rock 'n' roll! My big chance to cavort like a chimp with Attention Deficit Disorder in front of appreciative rock 'n' rollers! My big chance to make a fool of myself in a way that I might never get a chance to again.

So I joined up. It was an unwieldy combo, with an unwieldy name: The Rock-Bottom Remainders. All these big shots were in it—Stephen King, Ridley Pearson, Dave Barry, Roy Blount Jr., Barbara Kingsolver, Al Kooper, Tad Bartimus, Robert

Fulghum, Amy Tan—not that I'm dropping any names—and I was secretly there as a fan. Turned out, because of my shameful past, I got shoved into the rock-critics' chorus, along with Greil Marcus, Dave Marsh, and Joel Selvin. Oh, the shame of it. Anyway, over the course of many rehearsals and performances I found that my part in the band kept getting reduced further and further, till I ended up merely singing the titles of the songs. They even took away my tambourine. For the good of the band, and for the good of Western culture, I knew this was the right choice. (The sordid details of this whole mess are set forth in the group-written book *Mid-Life Confidential: The Rock-Bottom Remainders Tour America with Three Chords and an Attitude.*

The Rock-Bottom Remainders had its biggest "gig"—that's rock lingo for "giggle"—at the Hollywood Palladium, when we performed for some three thousand booksellers who were in town for a convention. Throwing caution to the wind, I strutted and howled like only a stiff, forty-year-old cartoonist can, wearing a succession of stupid hats and bootleg Simpsons T-shirts to let everyone know I wasn't taking this seriously. But in my heart of hearts, I was pretending I was a real rock star, or at least a member of My Head Itches.

The high point came during our encore of "Gloria," when we were joined onstage by Bruce Springsteen. This name may mean little to our younger readers, but I assure you, the presence of Bruce Springsteen onstage with the Rock-Bottom Remainders both woke up *and* impressed the hell out of the crowd of middle-aged booksellers. And the band was in heaven, too.

We cut loose, man.

We let it all hang out.

We . . . dare I say it?

Yes.

We jived.

And after you've jived, what else is there to say?

—The Artist Formerly Known As Matt

SON OF ADVICE TO YOUNG CARTOONISTS

Here are a few more tips about being a cartoonist, along with a few observations about life in general.

1) Observation #1: Man, it's fun to give advice.

2) So you really want to be a cartoonist? I mean, you really, really, really want to be a cartoonist? Then I have some good news for you: Everything you study in school, every book you read, every party you go to, every movie and TV show you watch, every comic book you read—is all part of your training. (Except algebra.) Now you can relax and enjoy it all.

3) Just be sure to pay attention, observe people's behavior, and remember everything you can. Keep a journal if you dare. (This is general advice, not just for cartoonists.)

4) You may very well be stuck in some crummy little town in a crummy little school with a bunch of snobs and jerks and bullies tormenting you all the time. That's why you're hiding in the back of the classroom, reading this instead of paying attention to the teacher, right? OK, I sympathize with your personal hell—I've been there, man—and it's not much consolation, but here goes, anyway: All the great cartoonists you dig went through what you're going through right now. (And the secret fact of the matter is that a few—maybe even a lot—of the kids sitting near you right now are just as sensitive and bitter and scared as you are. But no one will ever admit it.)

5) Don't hang out at the mall too much.

6) Read all sorts of cartoons and comic strips, not just the ones that currently grab your mutated pubescent fancy.

7) Go to the library and look at histories of comic strips.

8) Gary Panter, creator of JIMBO, has this to say: You're going to be better 300 panels from now (so cheer up and get drawing). (The parenthetical remark is mine.)

9) Gary also says: No one will ever see it if you don't show it to anyone.

10) Gary also says: Don't do comics about sitting at your drawing table not having an idea about what to draw.

11) I'm guilty of the above crime.

12) Try to jump out of your reading rut. If your favorite comic book is *Spider-Man*, try reading some Dostoevsky. (If your favorite author is Dostoevsky, you're probably not reading this book.)

13) If you draw comics with panels, please, I beg you: Try to actually draw the panels so the lines connect—just like little boxes. You can't believe how much a solid-looking panel will help a wobbly drawing, and you can't believe how many comics with botched drawings of panels I'm asked to look at.

14) I said this last time, but it's worth repeating: Finish your work!

15) Don't lend your original art to your friends. Give 'em photocopies.

16) You're keeping a sketchbook, aren't you?

17) Take art classes if you can. If not for the art, then for the other kids. Art class is where most of the coolest weirdos in school wind up.

18) All through my troubled teens, guidance counselors, teachers, parents, and friends all told me to set my sights lower, to be less ambitious, to not go for the thing I really wanted to do. It's difficult, but try to stay true to your ambition: Don't let people discourage you from cartooning (or whatever you know you'd love to do) if that's what you really want to do.

19) I'll close with a final piece of advice from Gary Panter: Do it for love, because it's harder to sell out than you think.

Your pal,

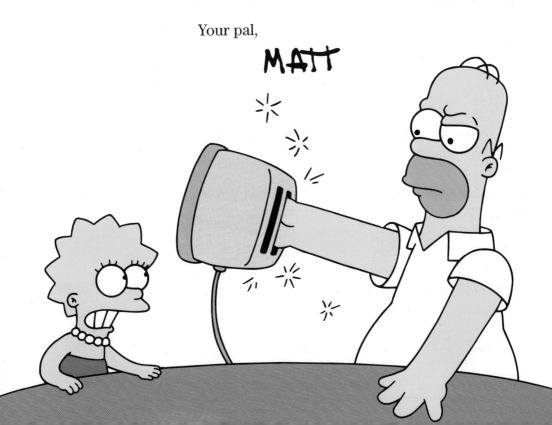

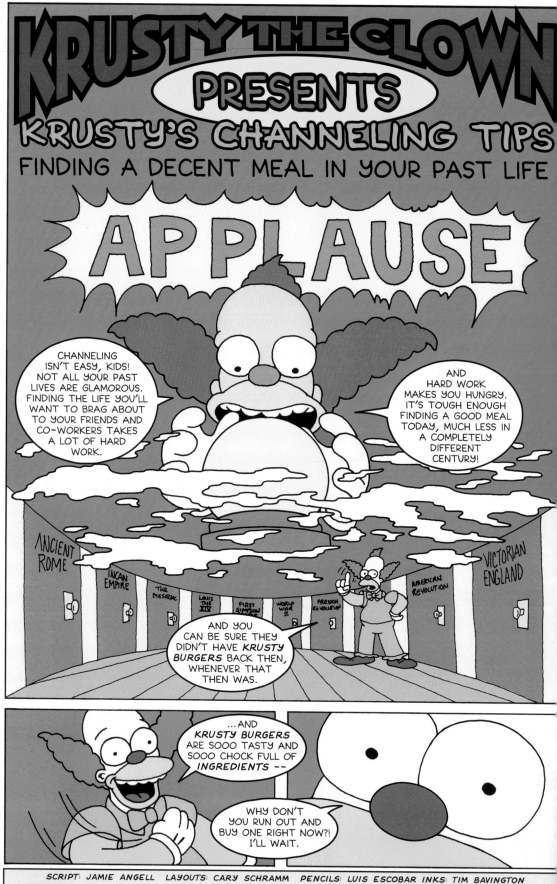

SCRIPT: JAMIE ANGELL LAYOUTS: CARY SCHRAMM PENCILS: LUIS ESCOBAR INKS: TIM BAVINGTON
COLORS: NATHAN KANE LETTERING: STARKINGS/COMICRAFT MYSTIC CHANNEL CHANGER: MATT GROENING

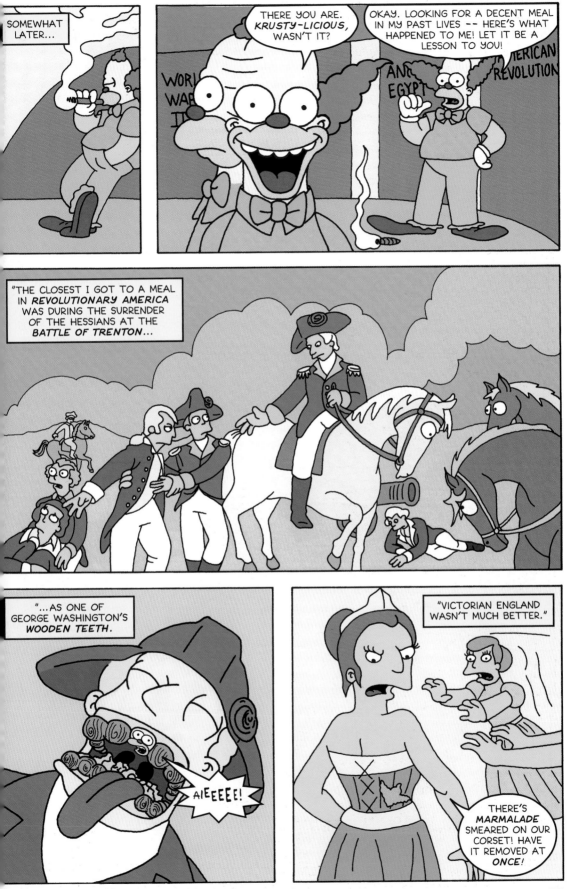

SOMEWHAT LATER...

THERE YOU ARE. *KRUSTY-LICIOUS*, WASN'T IT?

OKAY. LOOKING FOR A DECENT MEAL IN MY PAST LIVES -- HERE'S WHAT HAPPENED TO ME! LET IT BE A LESSON TO YOU!

WORLD WAR II

ANCIENT EGYPT

AMERICAN REVOLUTION

"THE CLOSEST I GOT TO A MEAL IN *REVOLUTIONARY AMERICA* WAS DURING THE SURRENDER OF THE HESSIANS AT THE *BATTLE OF TRENTON*...

"...AS ONE OF GEORGE WASHINGTON'S *WOODEN TEETH*.

AIEEEEE!

"VICTORIAN ENGLAND WASN'T MUCH BETTER."

THERE'S *MARMALADE* SMEARED ON OUR CORSET! HAVE IT REMOVED AT *ONCE!*

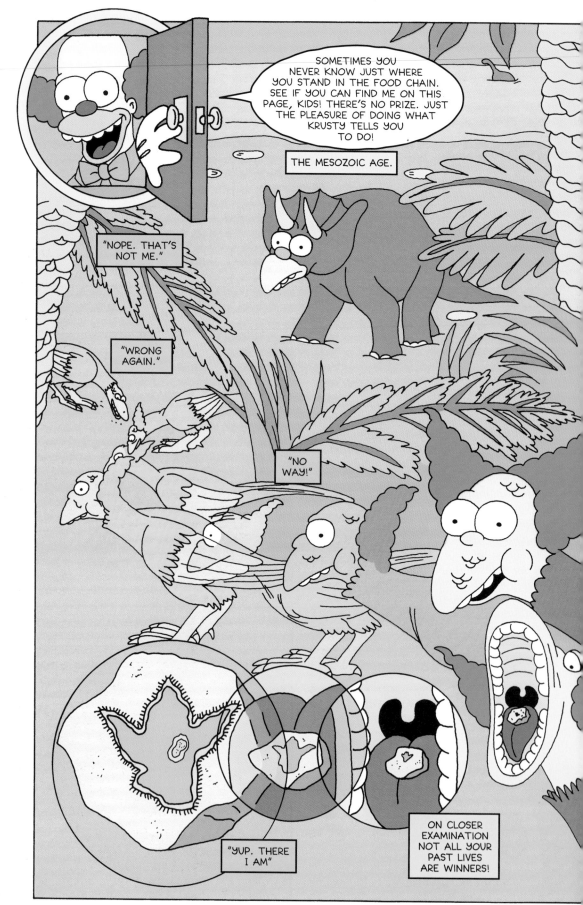

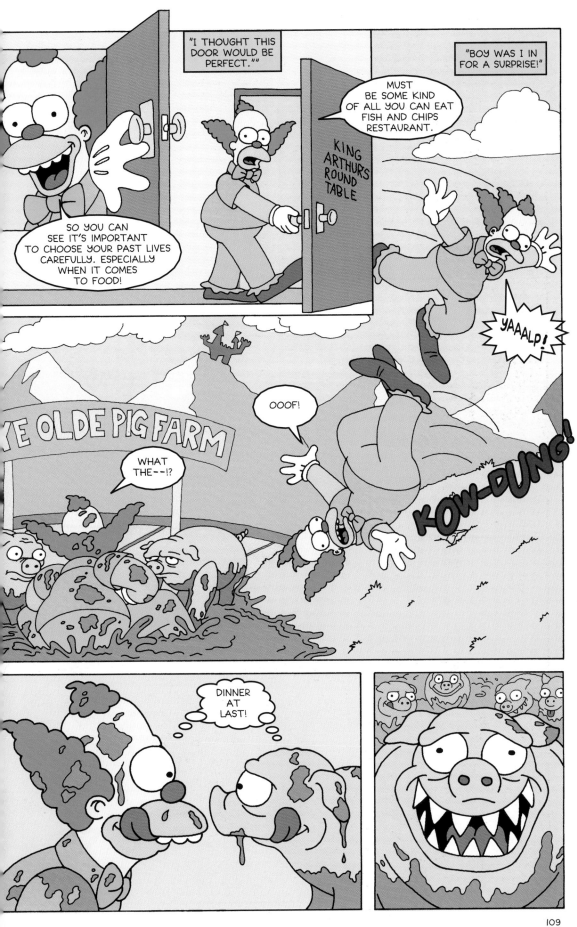

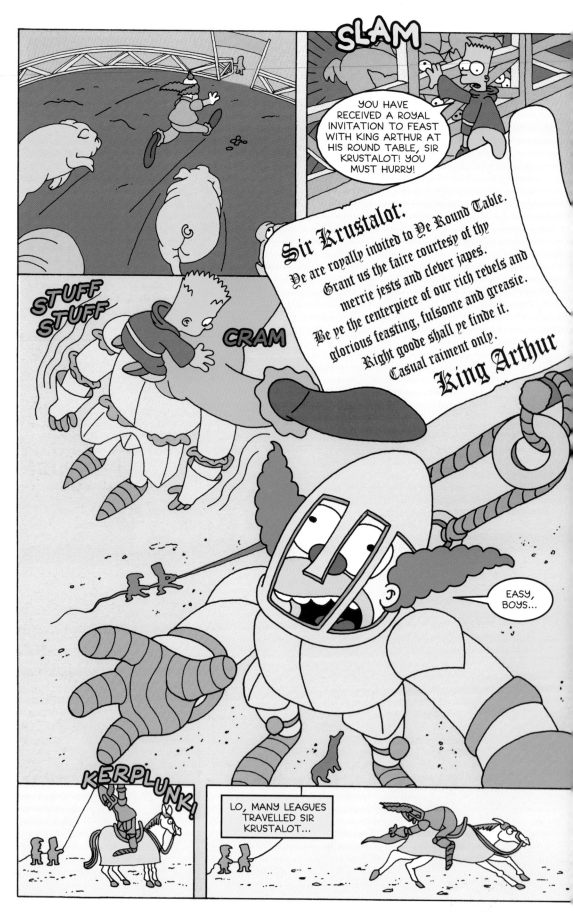

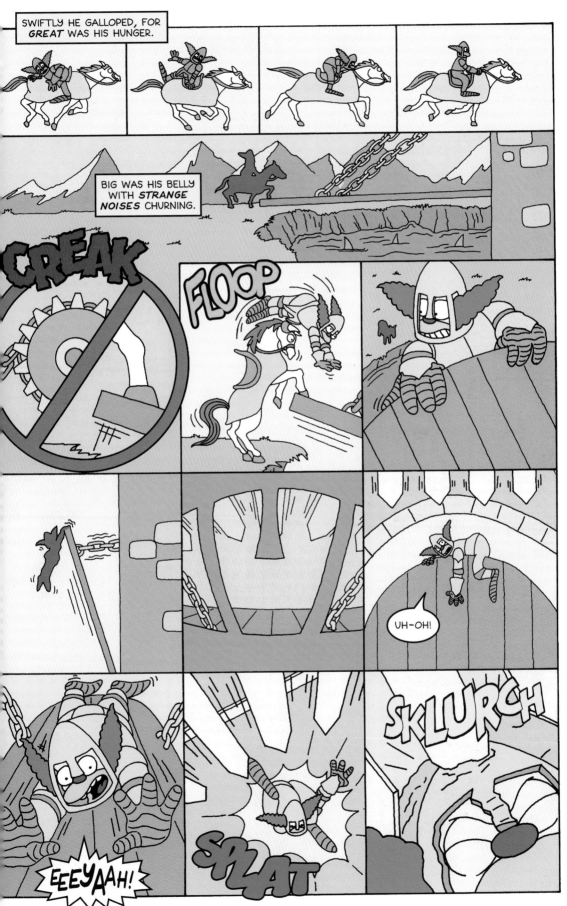

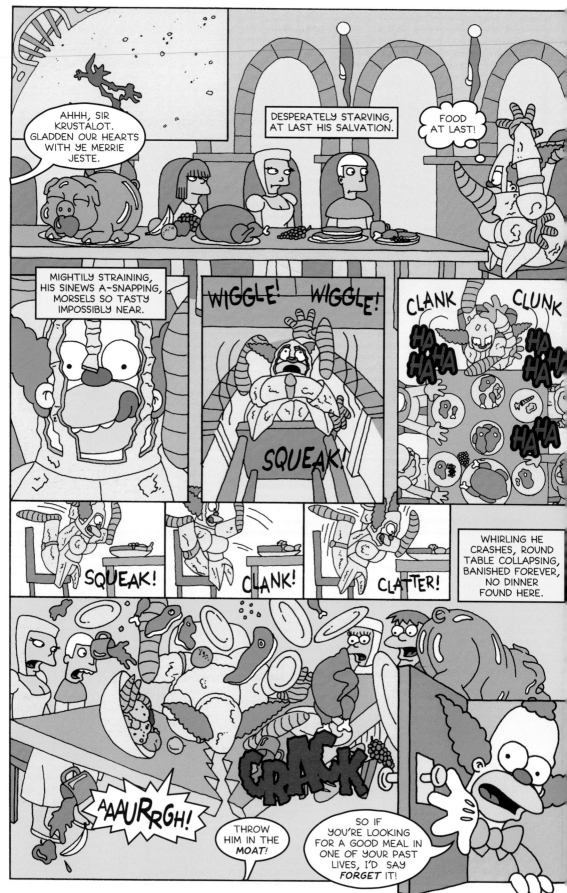

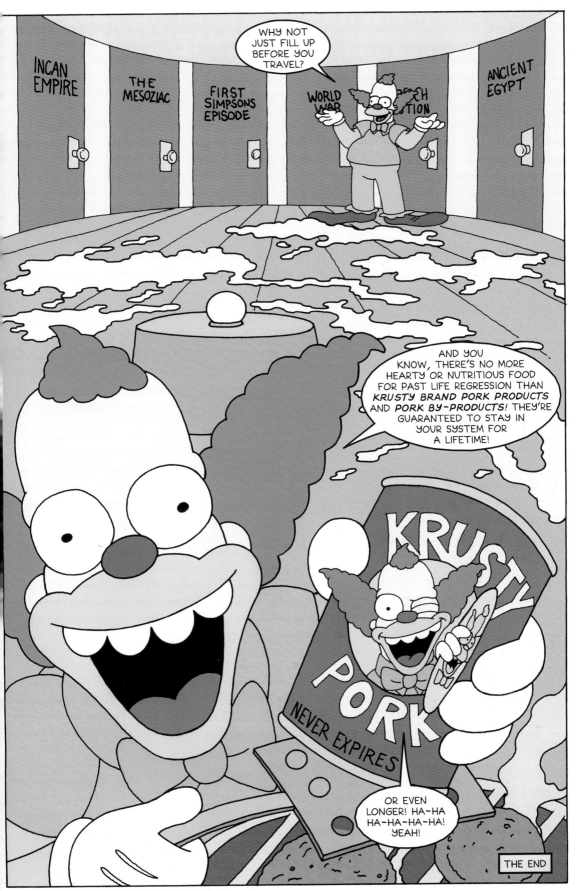

MY PERSONAL SLANG DICTIONARY, PART TWO: FROM *GRAND POOH-BAH* TO *WIMP*

As a public service, here we go again with more slang terms from the olden days of the nineteen-sixties, when I slouched around with a skateboard, chewed gum in class, and most inexplicably of all, wore a Greenie Beanie. (A Greenie Beanie was this little hat that you could grow grass out of the top of.) (All the kids wore 'em.) (Well, several of us did, anyway.) (I'm not making this up.)

Enjoy these slang terms, kids.

Feel free to use 'em.

Remember: Many of these words are as annoying now as they were then.

grand pooh-bah: The leader of the Komix Appreciation Klub, a club that my pals formed in high school. We thought that misspelling our club's name was ultra-klevver.

grounded: The state of being confined to one's home as a punishment by one's parents or guardians. See *Sneaking Out*.

hang ten: Originally a surfing term, referring to the wave-riding trick of hanging all ten of one's toes off the front of the surfboard. In my landlocked neighborhood in Portland, Oregon, this was strictly a skateboarding term. Executing this move was usually followed by a "wipe out." (In the Simpsons universe, of course, the term is "hang eight.")

hassle: 1. A difficult task, as in "Doing homework is a hassle, man." 2. To be bugged or bothered, as in "My parents really hassled me just 'cause I won't do my homework, man."

I know you are, but what am I?: Handy retort to all insults. Much snappier than "Sticks and stones will break my bones but words will never hurt me," which may only serve to encourage bullies to break your bones with sticks and stones.

I'm fourteen and funky: When I was in high school, this "Up With People" singing group performed at an assembly, and one of the kids onstage actually said these words. For the rest of the time I was in high school, whenever someone acted like a self-satisfied jerk, one could point this out to them by saying, "I'm fourteen and funky."

knuckle sandwich: Traditional term of threat, euphemistically describing a fist in the face. Used in the rhetorical question, "Are you lookin' for a knuckle sandwich?" Bullies actually said this without irony, but woe unto the young intellectual who snickered at such antiquated locution.

let it all hang out: My cartoonist pal Lynda Barry claims kids in her neighborhood said this, but I only heard it on TV or in bad pop songs. Lynda says it means to totally relax, man.

let the baby have his way: A phrase used by one of the losers in a dispute, usually over a game of some sort, to point out that the triumphant participant in said dispute has used infantile tactics (pouting, whining, etc.) to persuade the others. Absolutely infuriating to "the baby."

look up, look down, look at my thumb—gee, you're dumb: Kindergarten playground game. Variations include "Look up, look down, look around—gee, you're a clown" and "Look up, look down, look over there—gee, you're a square." Game gets old by the first grade.

more funky than groovy: Sarcastic retort to anyone using the word "groovy" seriously.

nothing's impossible: Philosophical statement used in a speculative discussion. Example: Frustrated Kid: "Are you saying that a little baby could count all the grains of sand in the world in a fraction of a second?" Young Philosopher (blandly): "Nothing's impossible."

no way: No. Often used in the phrase "No way, man," or more cornily, "No way, José."

ralph: To vomit. (This word makes life difficult for kids named Ralph.)

sorrow: Sarcastic mispronunciation of the word "sorry," used in false apologies. I believe this slang term was unique to the boys in my sixth grade class. Example: "You broke my skateboard, man!" "Sorrow."

tinkle-dinkle ha-ha room: The bathroom. Taken from an old routine by the comedian Lenny Bruce. Used with coy sarcasm in front of friends' mystified parents, as in: "Could you direct me to the tinkle-dinkle ha-ha room, please?"

wiener dog: Fun term for dachshund.

wimp: 1. A weak person. 2. anyone disliked by the speaker.

Well, that's all for now. One of these days I'll get around to "wipe out," "wise up," "wowie zowie," "yeebolee," "yeeboliah," "you bet your sweet bippy," "you're cruisin' for a bruisin'," "yuck," "zillion," and "zit."

In the meantime, stay groovy. Or better yet: Stay more funky than groovy.

Your pal,

MATT

WHY BART'S HAIR IS SO SPIKY, PART ONE

I hate haircuts for several reasons.

For my whole life, barbers have always seemed to dislike me. Sure, they've smiled and made pleasant small-talk, but I don't think they were ever really my true friends.

I say this based on the evil things they did to my head when I wasn't looking. I say this because, whenever I walked out of the barber shop with a fresh new look, my pals would say, "Nice soup-bowl cut, man."

So I've always avoided barbers as much as possible, which invariably has led to long hair, which in turn has caused the main authority figures in my life to really get on my case.

These authority figures include:

My dad, Homer.

My mom, Margaret (popularly known as Marge, although that's not her name).

My old Scoutmaster.

My high school vice principal.

My high school football coach.

A Moroccan border-guard.

Assorted ex-girlfriends.

My bad haircuts started when I was a little kid in Portland, Oregon. My mom would give my older brother Mark five bucks, which was good for a couple of good, normal $1.25 haircuts, a snack, and bus fare. But the second we got out of the house, Mark would swear me to secrecy, then he'd take me downtown, where we'd end up, not at a regular barber shop, but at . . . the Moler Barber College.

The Moler Barber College looked like a regular barber shop, only bigger and scarier. Instead of a couple of barber's chairs, there were two rows of twenty, and instead of a few clumps of hair on the floor, there were big, menacing piles. Tangy, conflicting hair-cream smells hung in the air, and we were always the only customers in the place.

Mark would get the 75-cent haircut, which meant he got his hair cut by an advanced student. Mark always had me get the 50-cent haircut, which meant I got my hair cut by a beginning student. I remember seeing these guys shake with nervousness as they cut my hair, while I tried to distract myself by looking at the frightening hairstyle charts on the wall.

After the torture, we'd walk around the corner to the Blue Mouse Theater while my brother exulted about the money we'd saved. At the Blue Mouse, we'd watch part of a triple-bill of faded, scratched-up, second-run movies and eat really bad popcorn. I remember feeling my denuded noggin in the dark, wondering how bad my haircut really was. I also wondered why a movie theater was called the Blue Mouse.

Afterwards, we'd take the bus back home. If I sniffled, Mark would try to

cheer me up by regaling me with tales about his amazing invisible friend Tom, who had an invisible airplane, and who would take me up to the clouds where he lived, where he had one of every kind of toy in the world—if I knew how to keep my big trap shut. I was doubtful, but I kept my big trap shut anyway.

Back home, our mom would inspect the haircuts.

"The quality of barbers has certainly gone down," she'd say, frowning. "Your haircuts are all choppy and uneven. Especially yours, Matt."

After a couple of years of our little barber-shop subterfuge, with a series of really awful, goofalicious haircuts, our mom got fed up.

"I'm not paying good money for these bad haircuts anymore," she said. "I'm going to cut your hair myself."

And that's when my real troubles began.

(To be continued . . .)

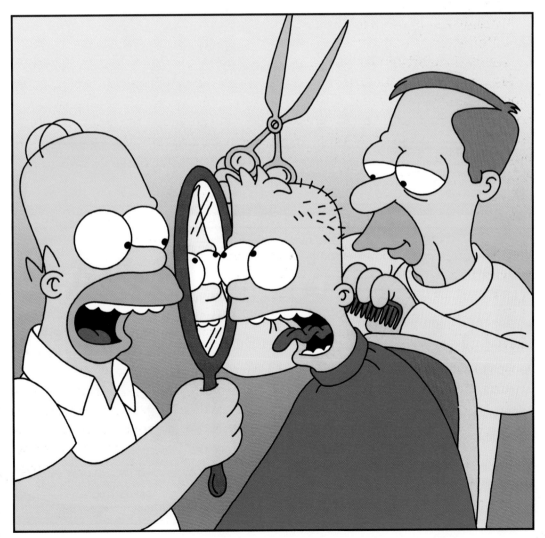

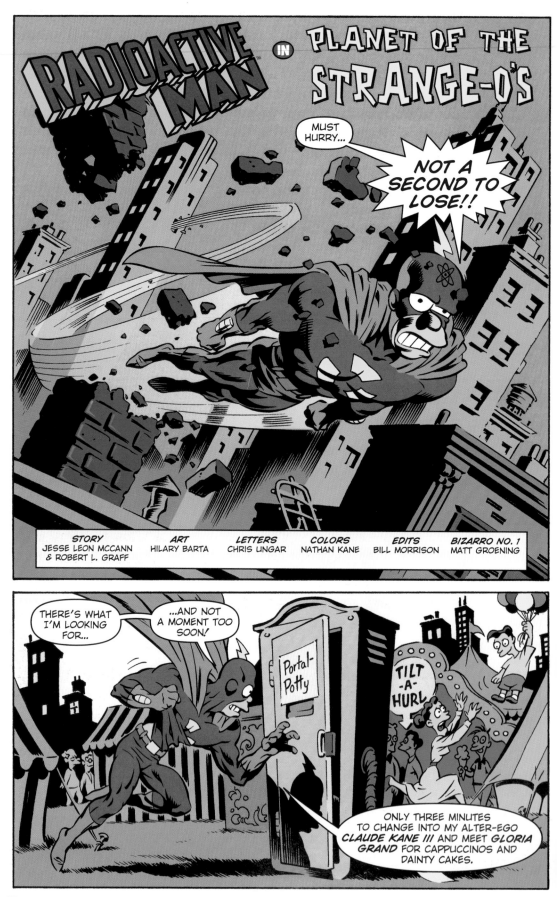

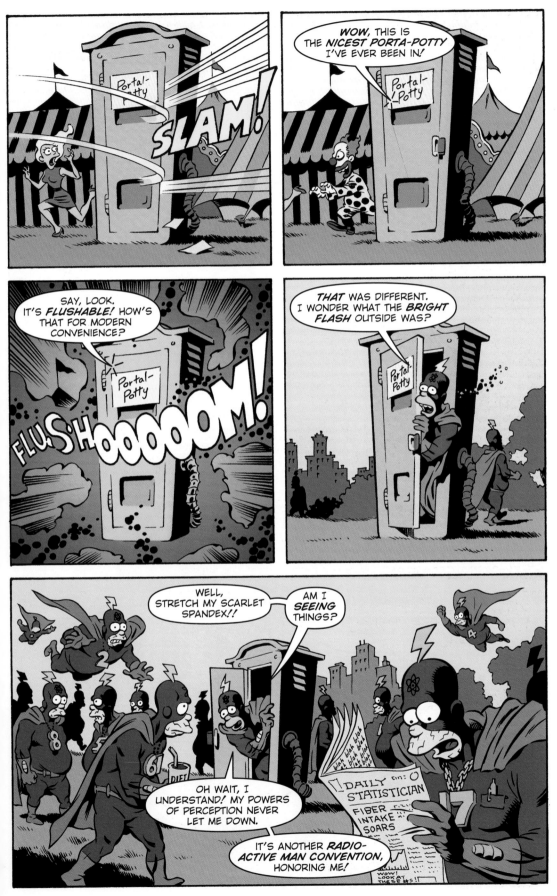

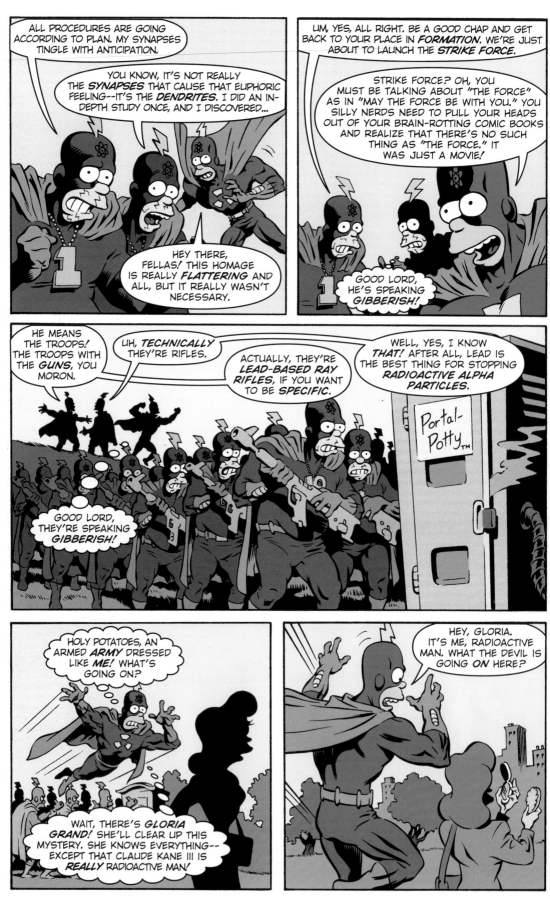

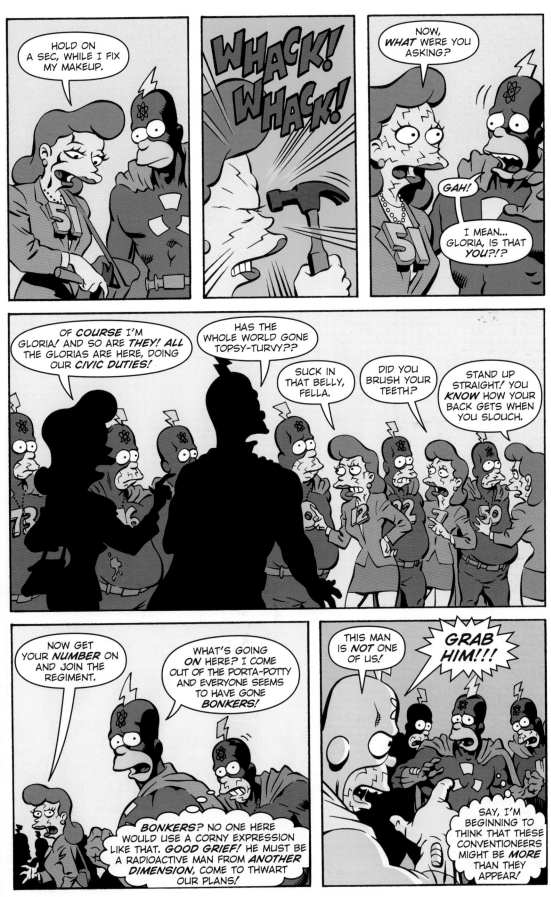

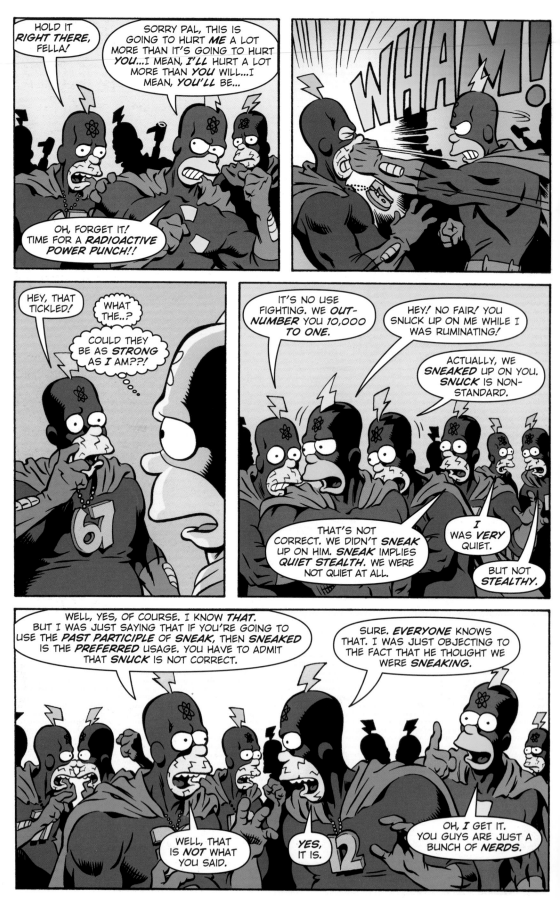

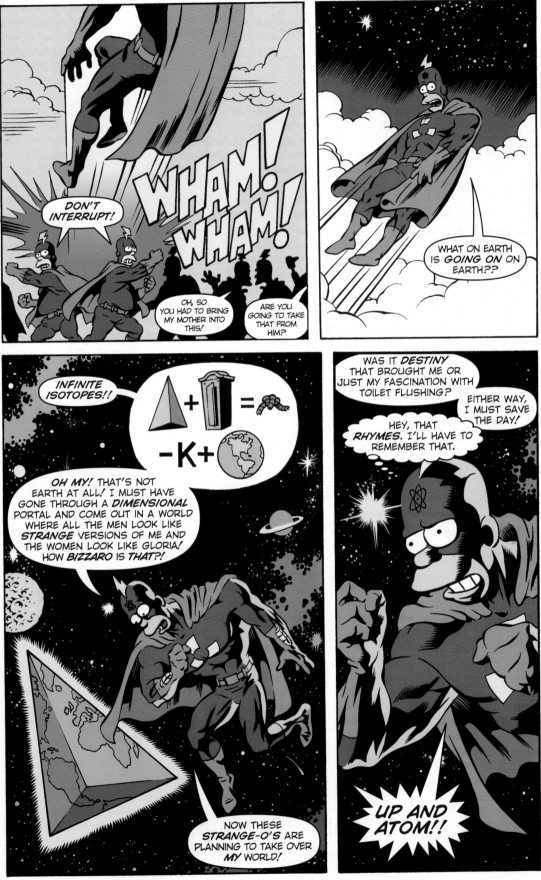

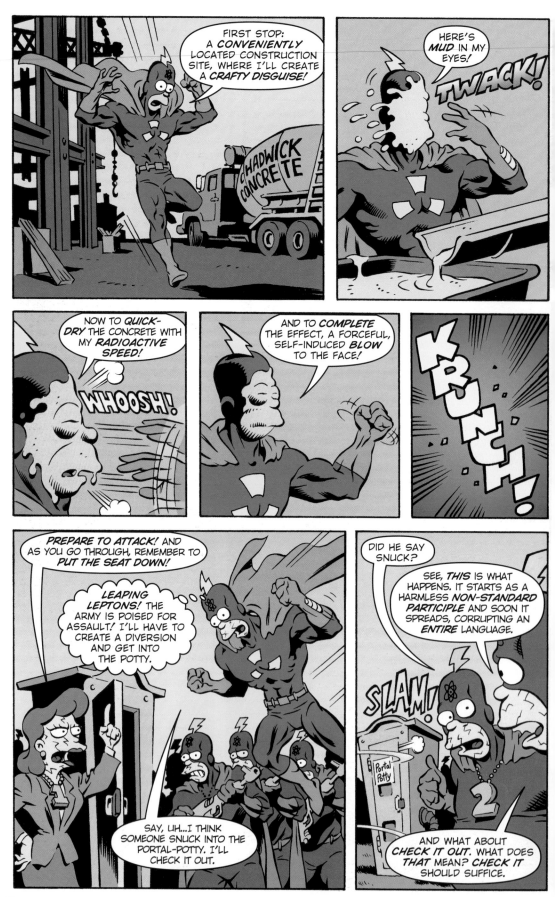

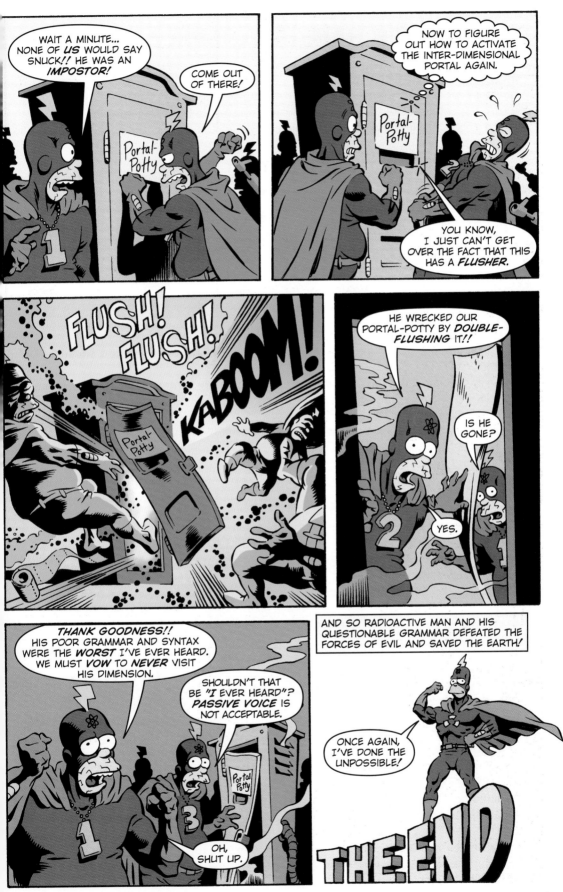

WHY BART'S HAIR IS SO SPIKY, PART TWO

More reasons I hate haircuts:

My mom cut my hair for several horrible years when I was a kid, using a big, ugly, brown electric clipper that looked like a torture device from an old Buck Rogers serial. Instinctively, I felt no good haircut could come from such a weapon, and I was right. The haircuts were lousy, but that wasn't the worst part.

Things would be going along miserably, with me slumped over in a chair in the kitchen while my Mom buzzed away at my head, my precious, strength-giving hair dropping left, right, and down my neck.

Then, suddenly, the electric clipper would graze my ear, and blood would come out.

"Ow!" I'd yelp.

"Sorry," my mom would reply. Then: "Stop squirming. That's why I cut you."

It was very hard to stop squirming.

My mom kept practicing horrible haircuts on me for five years. Because I knew one of my ears might get gouged at any second, I'd flinch a lot. My flinching would fluster my mom, and sure enough, I'd feel a sudden sharp pain, and my ear would be bleeding again.

"Ow!" I'd yelp. "You got me again!"

These injuries were inflicted on me a couple dozen times over five years, which is a lot, if you think about it. And if you think about it a little bit more, it seems like a whole hell of a lot.

The haircuts stopped when I was thirteen, the year I learned how to swear. My mom nicked my ear, and this time I didn't yelp "Ow!"

This time I yelped, "#*$@!"

We mutually agreed I would go to a real barber from then on.

I was in the Boy Scouts at the time, and in July, 1967 (ironically, the Summer of Love), my Scout buddies and I took a chartered bus from Portland, Oregon, to the Philmont National Scout Ranch in New Mexico. Along the way, we stopped at Disneyland in Anaheim for the afternoon. We jumped off the bus and lined up in the parking lot for inspection, with big smiles on our faces.

This was going to be great!

The Scout leader decided my hair was too long for Disneyland.

My hair? Too long? But I was a Boy Scout! In full uniform! Patriotic! Short hair! Salute the Flag! Gah! This was insane!

So while the rest of the kids traipsed off to Tomorrowland, I stood there forlorn in Goofy Lot.

Eventually, I found myself trudging over to the Disneyland Hotel, where I got my short hair cut even shorter in the hotel barber shop.

The second I got home, I quit the Boy Scouts.

"What?" my mom said. "Are you going to become a hippie?"

"No," I replied in my sulkiest thirteen-year-old sneer.

Yes! I silently screamed.

I immediately began immersing myself in the Beatles, Frank Zappa, the Fugs, Captain Beefheart, and Jimi Hendrix. I began reading *Catch-22*, *Catcher in the Rye*, *Cat's Cradle*, and *Candy*. And my hair began to grow.

Suddenly, my mom came into my bedroom with the electric clippers. "You're getting a haircut," she said.

"Whadja say?" I replied. I couldn't hear her through the headphones.

An argument ensued, and we ended up in a compromise. My mom would go shopping in Beaverton, and I'd go with her and get my haircut at a Beaverton shopping center.

She dropped me off at the barber shop, and when I walked in I immediately knew something was wrong. The barber and the two old duffers sitting there stared at me, then started elbowing each other and chuckling at my hair.

I sat down and picked up a *Men's Action* magazine. The snortling and muttering continued. I slumped.

Finally the barber cleared his throat. "Hey, boy," he said with a sneer. "I'll give you five dollars if you let me cut it all off."

I couldn't let them get the best of me, so I sneered back. "OK," I said.

I sat there in agony, my nose buried in the magazine, listening to the scissors snipping, and getting more miserable by the second.

Finally the barber said, "You're next."

I stood up and swaggered over, chin thrust out defiantly.

"I'll be right back," I said.

I ran out of the barber shop and never looked back.

My mom was bugged.

"The barber was going to pay you to get a haircut, and you turned it down?" she asked in disbelief.

"Yeah, well," I countered.

She ended up giving me a vicious little haircut back at home, and it was small comfort that this time she didn't nick my ear.

Later, I grew my hair long again, stopped shaving, and went to a college full of hippies, where I blended in.

My haircut troubles were mostly over, except for one unfortunate incident in 1973, when I hitchhiked across the country and took trains around Europe. Everything went OK until I hopped on a ferry from Spain to Morocco in December, and was stopped at the border by a guard.

"Heepie!" he said. "Go beck to Spain."

I went back to my hotel, got out a pair of scissors, and under a ten-watt lightbulb in front of a dark little cracked mirror, gave myself the worst haircut I've ever gotten. I even nicked my ear.

"#*$@!" I said.

The next morning I went back to the Moroccan border. I presented my scarred noggin to the guard and he looked me up and down.

"Heepie!" he said. "Go beck to Spain!"

When I got back to Portland, my mom said, "For once you've got a nice haircut."

Later in the seventies, she said: "Why don't you get a nice perm, like that sportscaster on Channel 2? He looks really sharp."

Throughout the eighties, she said: "Why don't you shave off that beard? You'll feel so clean without it."

But in the nineties, she has stopped bugging me.

Uh-oh. I just realized something.

I just realized this doesn't explain why Bart has spiky hair.

Well, in a way, I hope it does.

Your pal,

MATT

THE SECRET LIFE OF LISA SIMPSON

Interviewers often ask who my favorite Simpson is, and although I must admit I identify with the problems and desires of Homer (drooling, donuts, Dadness, doofus-osity), my favorite character in Springfield is Lisa. I like her idealism, her stubbornness, and her ability to lift, let alone play, the cumbersome baritone saxophone. I like it that Lisa is mature beyond her years, yet is able to laugh her butt off at the crude antics of Itchy and Scratchy. I don't understand her obsession with ponies and Malibu Stacey dolls and accessories, but I do like Lisa's politics, convictions, and ability to learn from her mistakes. If I had to be suddenly transmorphed into the Simpsons cartoon universe (a horrifying thought), I'd like to be Lisa Simpson. I think this is because Lisa is the only character who probably could figure out a way to escape—at least from the town of Springfield.

Before I first designed the Simpsons in 1987, I'd spent my whole life doodling cartoon animals, mostly weird rabbits. I didn't really know how to draw humans—my humans always came out looking like friendly monsters—which is why I stuck to rabbits. Bitter experience taught me that if you draw a character with two big ears that stand up, nine times out of ten, no matter how crummy the rest of the drawing is, people will say, "Oh! That looks vaguely like a rabbit."

But the problem with drawing rabbits is that most rabbits look like other rabbits, and it's hard for the casual viewer to tell them apart. (For years I drew a rabbit named Binky—still do—but when it came time for me to design a rabbit son for Binky, I was stumped as to how to make them different from each other. Finally, I came up with the solution: I gave Bongo—Binky's son—just one ear. Instant recognition.) (Yes, Bongo Comics Group is named after Bongo the rabbit.) (See any of my cartoon books with the word "Hell" in the title for further details on rabbits.)

So, when it came time for me to overcome my artistic limitations and actually design a human family, I got very nervous. It turned out that designing Homer, Marge, and Bart was pretty easy, but when I tried to draw Lisa for the first time, I was stumped. At first I gave her pigtails, then a ponytail, then a Marge-style mini-bouffant, but nothing seemed right. My aim was to design a set of characters who would be, once they were famous, easily identifiable in silhouette. (Would-be cartoonists take note: this is Matt's How-to-Turn-Your-Crude-Little-Doodles-into-a-Cartoon-Empire Rule #1. Ignore it at your peril.)

The recognizable-in-silhouette test worked on Marge, Homer, and Bart, but Lisa was a tough one. I tried giving her dreadlocks, but that didn't work. I tried giving Lisa little frizzy lines for hair, but that didn't pass the silhouette test. I even tried making her bald. Didn't work.

Finally, in frustration, I gave Lisa a modified punk Mohawk hair-do, and voila! Lisa Simpson, the starfish-head we know and love, was born. (Maggie, of course, is a slight variation on Lisa.)

In my original design, Lisa had about twenty points of hair, and they were much longer and spikier, and she had a sour expression on her face. Since that time, both Lisa's look and her personality have softened. When drawn correctly (something I still find it difficult to do), Lisa has eight points of hair, and four lashes on each eye. She wears a duplicate of Marge's necklace (which in turn was inspired by memories of Wilma Flintstone). Lisa also almost constantly wears a strapless red dress with a pointy hem, which was inspired equally by the dresses worn by Little Orphan Annie, Little Lulu, and the hillbilly women in the L'il Abner comic strip. (Another plug: See *Cartooning with the Simpsons* for further how-to-draw tips.)

My favorite detail about Lisa is her musical virtuosity. In making Lisa a sensitive, smart, overlooked child, I also wanted to give her a remarkable talent, a talent that would be both a means of expressing the true depths of her soul, and a purely physical burden: hence the baritone sax—the biggest, honkin'est, most ridiculous saxophone of 'em all. The picture of an eight-year-old kid wailing away on a bari sax made me laugh, and also I saw it as a way of paying tribute to some of my favorite baritone sax players: Pepper Adams, Gerry Mulligan, and the great Harry Carney, who played with Duke Ellington for almost fifty years.

When you think about the futures of the characters in the Simpsons universe, it's hard to be hopeful. Homer doesn't look like he's ever going to get a better job, it's doubtful that Marge will ever get out of her rut in any meaningful way, and Bart—although not headed for prison, as some have predicted—does seem about to get on the Homer track of life. Which leaves us with Lisa and Maggie. As for Maggie, it's hard to tell: she's one dexterous baby, it's true, but that constant, obsessive pacifier-sucking and her silent, enigmatic reactions to almost all events make her seem a candidate for long, expensive years of psychotherapy, at the very least.

But what about Lisa? Will she continue to nurture her talents, or will she get discouraged by the indifference of her parents, teachers, and friends? Will she keep standing up for what she believes, or will she knuckle under and become like the rest of them? Will she stay in Springfield, or will she escape to a place where she is better appreciated?

It's hard to tell—we're talking about a cartoon, after all—but I'd bet on Lisa Simpson to get what she wants out of life. Bart may be an underachiever and proud of it, man, but Lisa is definitely an overachiever. And she's working on the pride part.

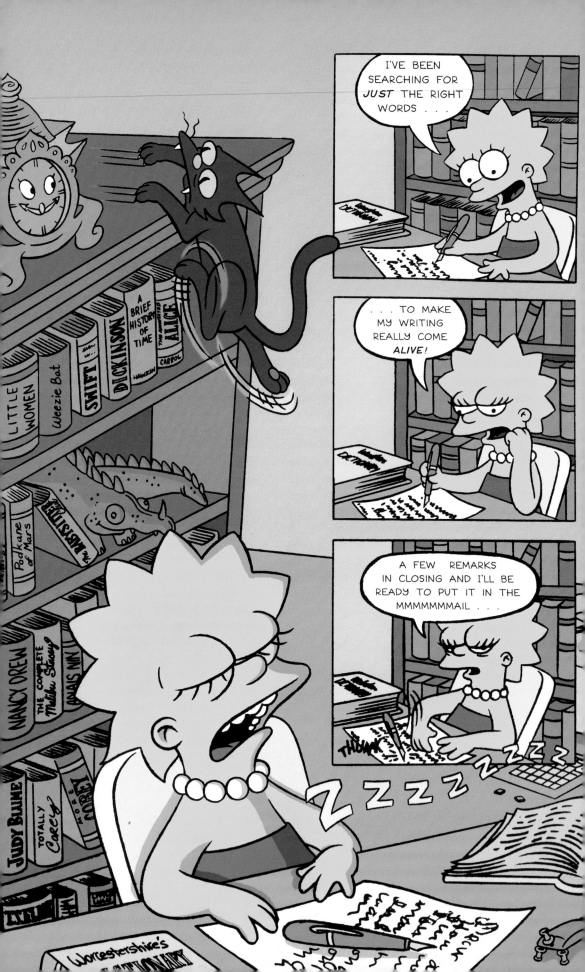

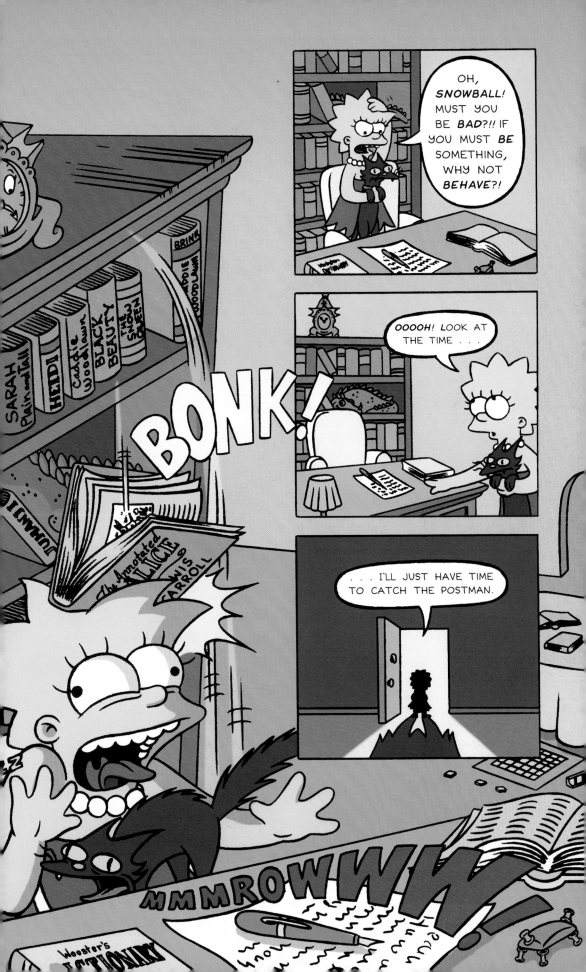

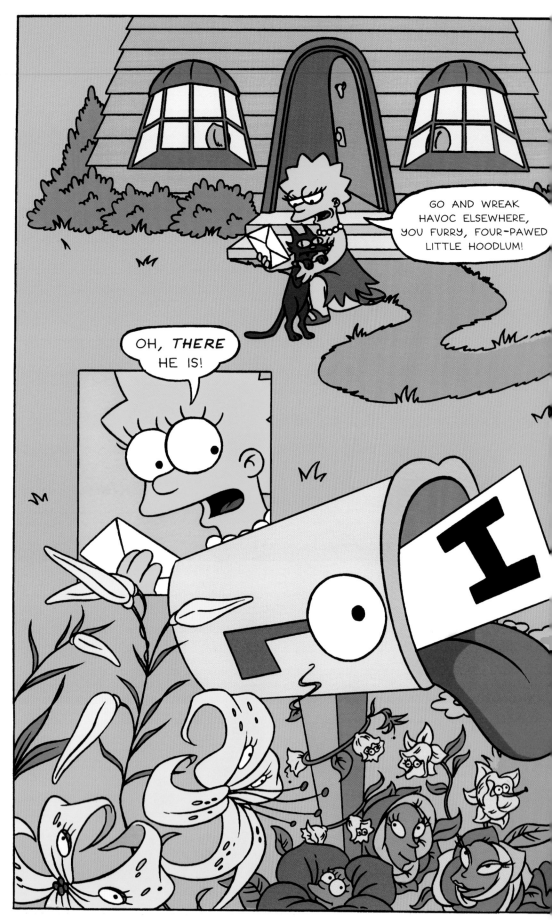

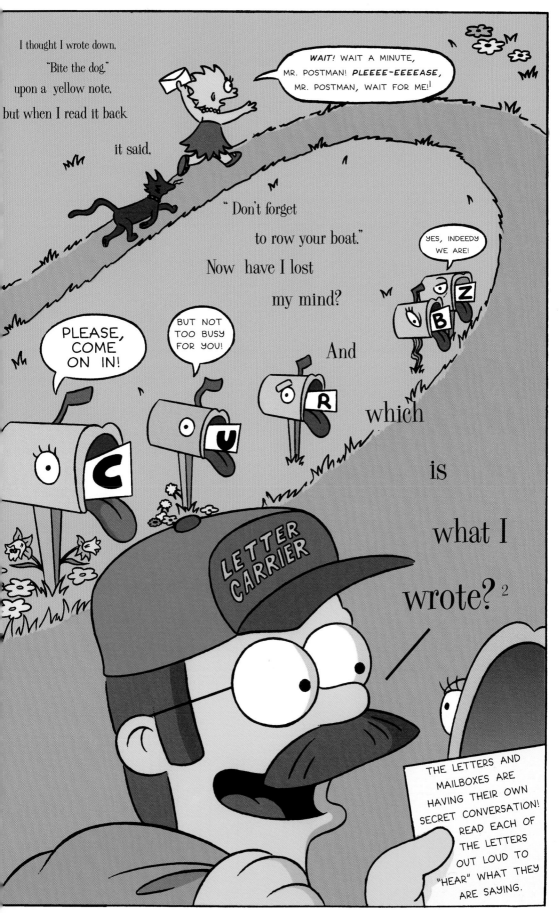

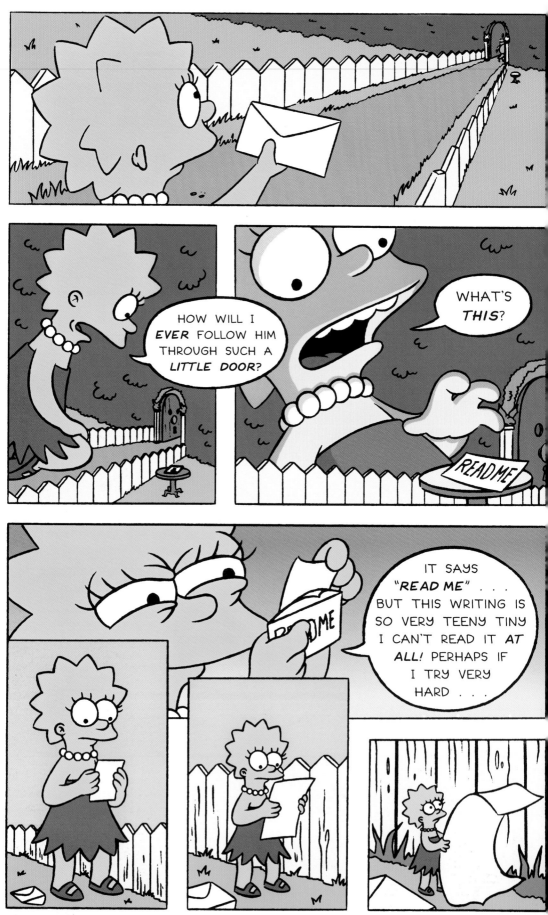

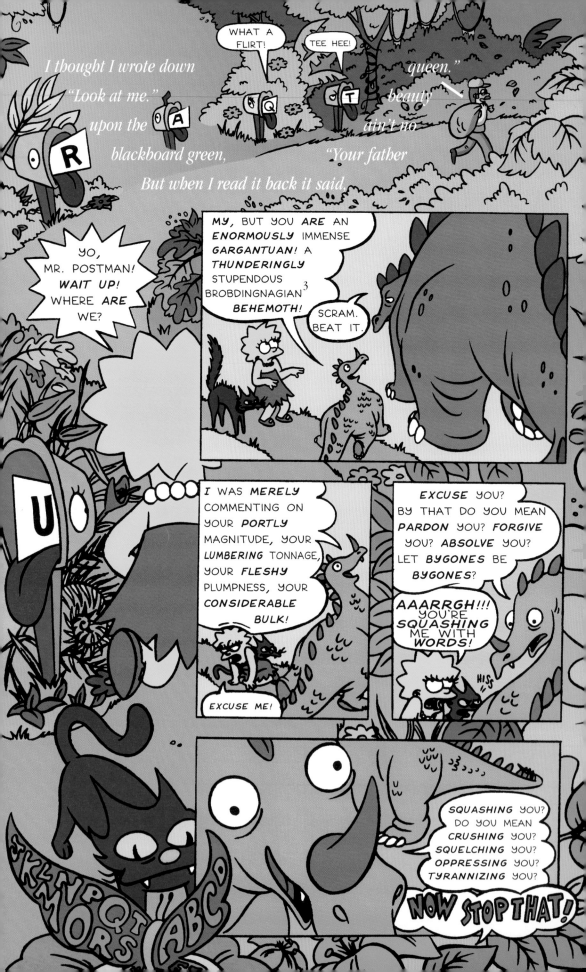

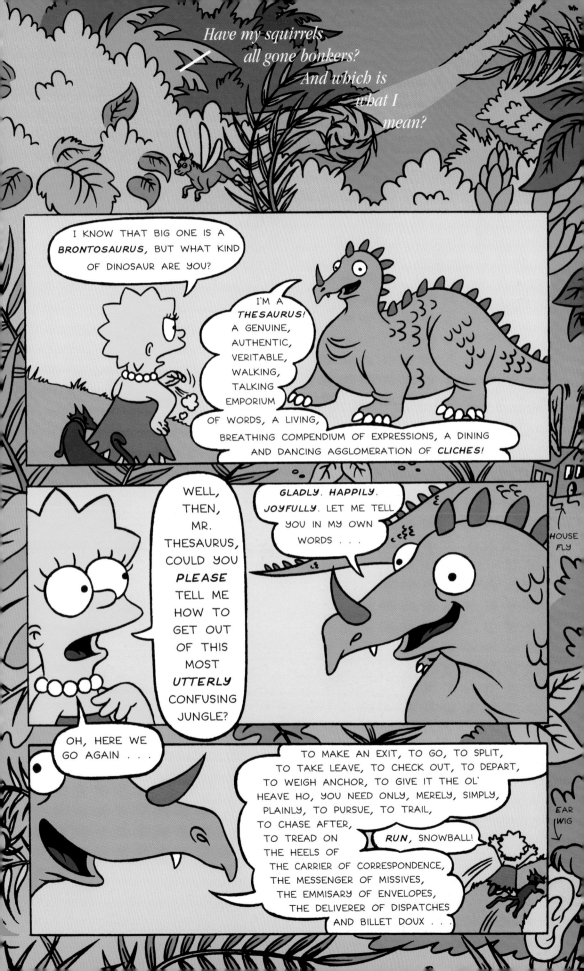

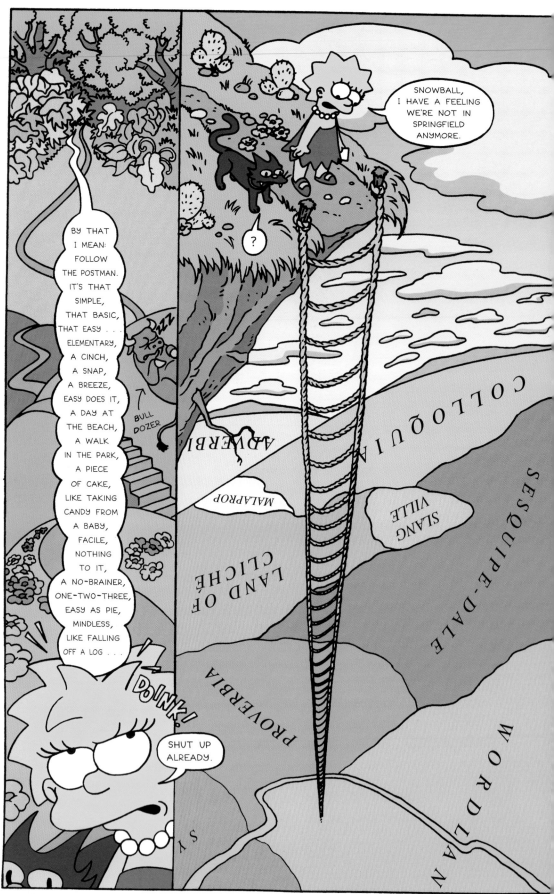

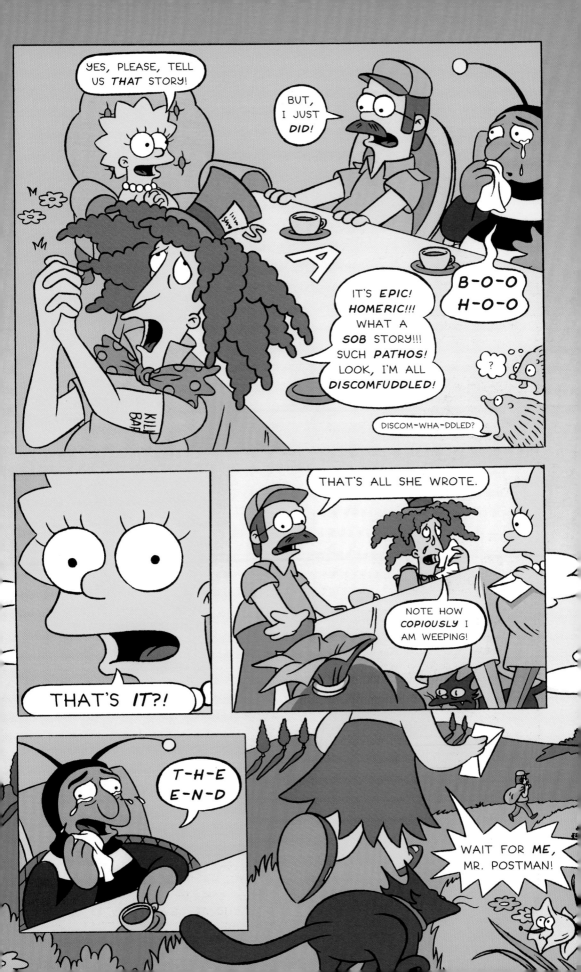

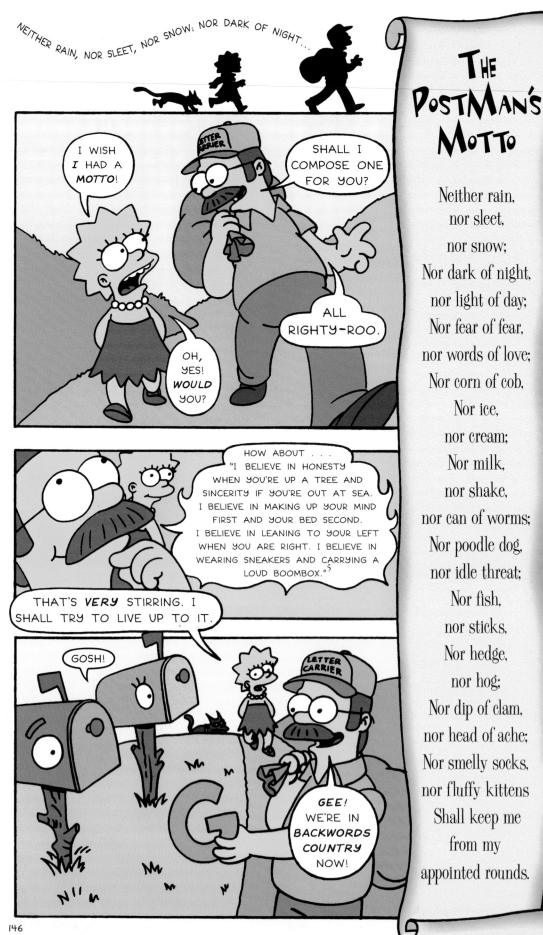

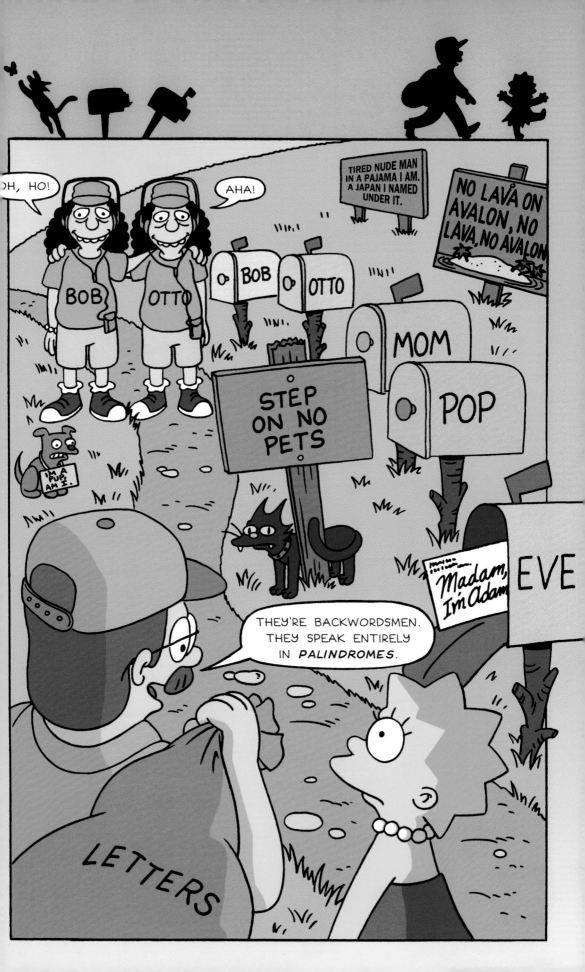

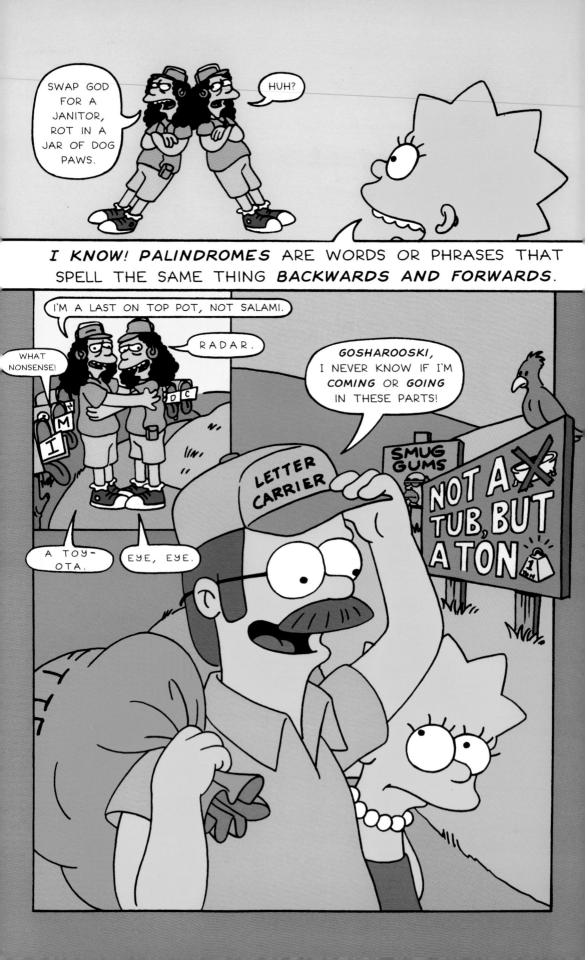

I thought

I wrote down,

"Spatulas"

along

the dotted

line,

but when I

read it

back

it said,

"Keep it up,

you're doing

fine."

Oh,

I've sprung

a leak

up in my attic,

and I'm

not yet

thirty-nine!

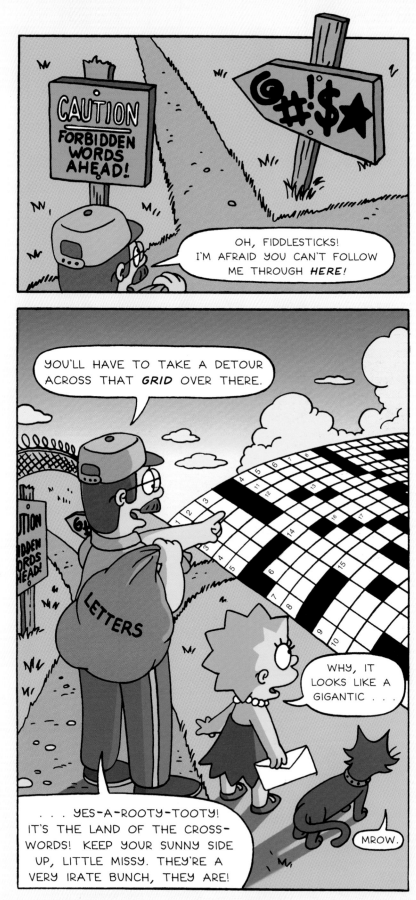

ACROSS

1. Throw a ____. Have a fit.
5. Parrot's complaints.
8. Sulk.
9. Hang around in a gloomy sort of way.
10. "I ___ care!"
12. "___ up!"
13. Jealous desire.
14. Complain.
16. Rode in ___ a broomstick.
18. Gets on one's nerves.
20. "What are ___ looking at?"
21. "___ way, José!"
22. "Stick it ___ your ear!"
24. Pain in the ___.
26. Glum; moody.
27. "Don't ___ an idiot!"
28. Sick and tired.
29. Rude; snappish.
33. Beat it!
35. ___ your face.
36. "___ lost!"
38. "What ___you looking at?"
39. "Go ahead. ___ if I care!"
40. Type of fuse or temper.
43. Long word for 'tude, dude.
44. Have a ___; throw a tantrum.
45. "___ if I cared!"
46. "Cut off your nose to ___ your face."
48. "Scram! Beat ___!"
50. "___ ___ shorts!" (2 wds.)
52. "What are you looking ___?"
53. ____ sport; bad loser.
55. Go away, insect! (2 wds.)
57. "You ___ goat!"
58. "___ what?!"
61. "Don't have ___ ___, man!" (2 wds.)
62. ___ again?! Weren't you just at 20 Across?
63. Like a mule.
64. Flip one's ____; go nuts.
65. "___ yeah?!"

DOWN

1. Type of tantrum.
2. Pain in ___ ___ . (2 wds.)
3. "Shut ___!"
4. Peevish.
5. Bee's insult.
6. Madder than a ___. (2 wds.)
7. Hissy fit.
11. Problems; worries.
12. Poor ___; bad loser.
15. "Kiss ___ foot!"
17. Get outta here! (2 wds.)
18. Rude remarks.
19. Mope; pout.
23. Mean; derisive.
25. Low-down; bottom of the barrel. (2 wds.)
30. Continuously scolds.
31. Crotchety; cranky; grouchy.
32. "It takes ___to know one!"
34. Type of words Lisa encounters on this page.
35. Irk.
37. Easily annoyed; petulant.
40. Spews saliva.
41. ____ one's feathers; be bothered by.
42. "Scram! ____ it!"
47. Peevish; ill-humored.
49. "___ fed up!"
51. Minor fight; squabble.
54. Cantankerous old poot; Oscar is one
55. Bird-____; idiot; moron.
56. Mutter like a dog.
59. "___ ___, not Yoko!!!" (2 wds.)
60. ____ the wrong way; give an annoying massage.

OH! I LOVE PUZZLES!

MROW!

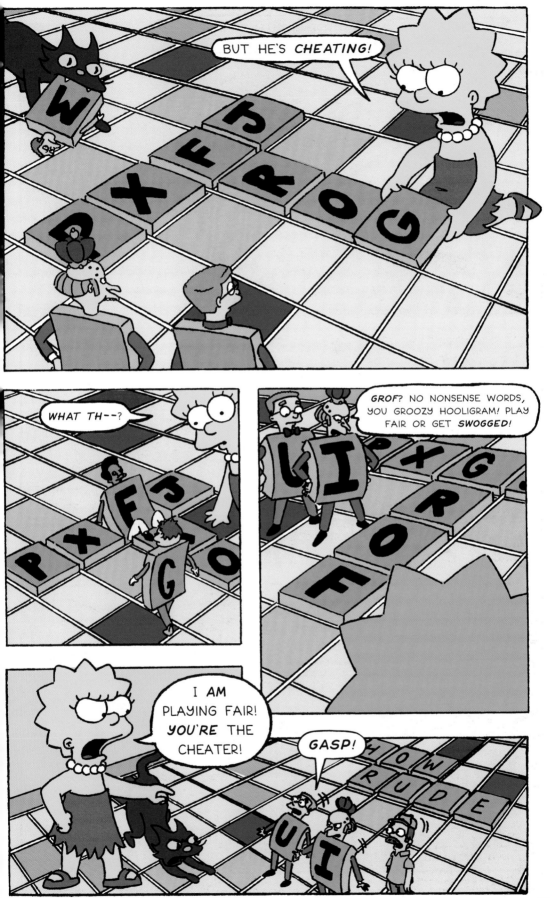

155

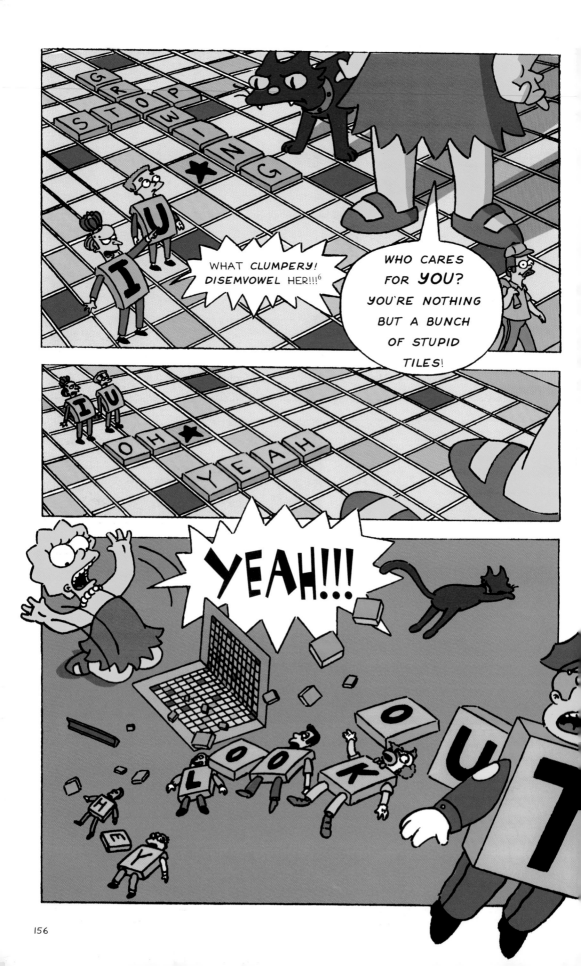

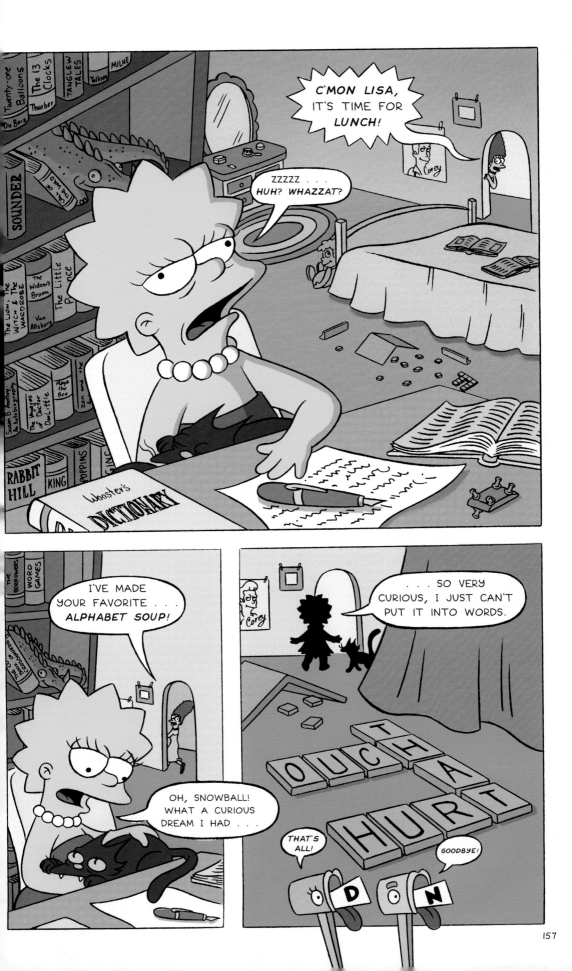

1

Unbeknownst to Lisa, she is sub-consciously repeating the lyrics to PLEASE MISTER POSTMAN (Dobbin - Garrett - Garman - Brainbert). First recorded by The Marvelettes at Hitsville (better known as Motown) in 1962. The Marvelettes were part of a genre of pop singers now known historically and reverently as "the girl groups". The Ronettes, Martha and The Vandellas, The Shirelles, and many others peaked and faded during that brief flash of time in the very late '50s and very early '60s, between Elvis and The Beatles. Incidentally, The Beatles included their version of "Please Mister Postman" on their first American released album "With The Beatles".

2

The Postman's Song, sung here by the affable and hi-doodly spirited Ned Flanders, is based on the wonderfully demented Gardener's Song from Lewis Carroll's *Sylvie and Bruno*. A much lesser known work than his *Alice in Wonderland* and *Alice Through The Looking Glass; Sylvie and Bruno* was Carroll's attempt to write a properly pious and morally uplifting book for children. Needless to say, it lacked the greater appeal of *Alice*'s absurd nonsense.

3

In *Gulliver's Travels* by Jonathan Swift, Brobdingnag was a country of giants. So big were these people that Gulliver was to them "not half so big as a round little worm plucked from the lazy finger of a maid." Hence the adjective, Brobdingnagian.

4

The quote "Eat a peach." is a snippet from T.S. Eliot's poem *The Love Song of J. Alfred Prufrock*:

I grow old . . . I grow old . . .
I shall wear the bottoms
of my trousers rolled.

Shall I part my hair behind?
Do I dare to eat a peach?
I shall wear white flannel
trousers, and walk upon the
beach.

It's most unfortunate that Eliot's parents named him Thomas Stearns rather than Stearns Thomas. That way, you see, he would have been S.T. Eliot . . . and Bob and Otto could tell you what *that* spells backwards!

5

The Postman is parodying Theodo Roosevelt's MY CREED:

I believe in honesty, sincerity, a the square deal;
in making up one's mind wh to do and doing it.
I believe in hitting the line ha when you are right.
I believe in speaking softly a carrying a big stick,
I believe in hard work a honest sport.

Teddy was the 25th President of t US (1901-1909). He was a progre sive, an optimist, a trustbuster, muckraker, a square dealer, and Bull Moose . . . He was also a bit o blowhard, but he meant well.

6

The Great Egomaniac threat to ha Lisa disemvoweled is unspeakab cruel and most unusual! This uniqu ly Wordland method of punishme would render her LS SMPSN!

Solution to crossword puzzle c page 150.

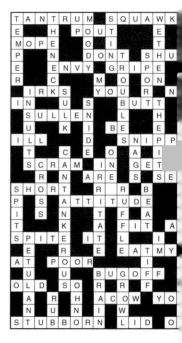

T	A	N	T	R	U	M		S	Q	U	A	W	K
E		H		P	O	U	T				E		
M	O	P	E		O		I				T		
P		N		D	O	N	T		S	H	U		
E		E	N	V	Y		G	R	I	P	E		
R		C			M		O		O	N			
	I	R	K	S		Y	O	U		R		N	
I	N		U		S			B	U	T	T		
S	U	L	L	E	N			L		H			
U		K		I		B	E		E				
I	L	L		D			S	N	I	P	P		
T		C		E		O		A		I			
S	C	R	A	M		I	N		G	E	T		
	R		N		A	R	E		S		S	E	
S	H	O	R	T		R		R		B			
P		S		A	T	T	I	T	U	D	E		
I		S	N		T		F		A				
T		K		A		F	I	T					
S	P	I	T	E		I	T		L		I		
E		R			E		E	A	T	M	Y		
A	T		P	O	O	R			I				
U		U			U		B	U	G	O	F	F	
O	L	D		S	O		R		R		F		
A		R		H		A	C	O	W		Y	O	
N		N		I					W				
S	T	U	B	B	O	R	N		L	I	D		O

GIVE A HOOT, READ A BOOK

I get letters every month from schools around the world asking me about my reading habits as a kid: Did you read a lot? How important is reading? What was your favorite book when you were growing up? Has any book changed your life? Do you still read? Would you send us some free Simpsons merchandise?

Sometimes these letters are written by dedicated teachers, driven to desperation by you subliterate young hooligans out there. Sometimes the letters are written by smart, well-read kids who actually want to know the answers to the questions the teachers have told them to ask. And sometimes the letters are written by you subliterate young hooligans, and your utter lack of enthusiasm for writing letters is apparent in every spelling error, indecipherable signature, and lack of return address.

This editorial is dedicated to all those letter-writers who forgot to put that crucial return address on their letter or envelope. (The word crucial means "of vital importance.")

I don't have a single favorite book. When I was a kid, my favorites kept changing. Before I could even read, I remember loving books by Dr. Seuss. The one that stuck in my mind the most was *On Beyond Zebra*, because it was full of spooky pictures of additional letters of the alphabet that Dr. Seuss made up. *On Beyond Zebra* made me feel creepy, but I kept coming back to it. I also liked looking at the pictures in the Curious George books because I could identify with a monkey who spilled ink and caused grown-ups to get upset.

I think I was so thrilled to be reading anything at all in the first and second grades that I loved everything, even the Dick and Jane books, that I could get my grubby little hands on. I remember having a sudden epiphany (epiphany: "a mind-blowing insight into the deep meaning of something, often inspired by a simple and boring occurrence") when I first figured out how to read the word "the."

In the third grade I began reading the Henry Huggins books by Beverly Cleary, which I liked a lot. Ribsy and Beezus and Ramona all seemed real to me, and the stories took place in my hometown of Portland, Oregon, which I found very exciting. I also liked *Stuart Little*, by E.B. White, and *Homer Price*, by Robert McCloskey, both of which had great illustrations.

In the fourth grade my favorite book was *Escape from Colditz*, by P.R. Reid. It was the true story of American and British prisoners of war during World War II, and how they repeatedly attempted to escape from the German castle prison where they were kept. I also read a number of other World War II escape books, including some sequels to *Escape From Colditz*, but the first one was the most entertaining.

A year or two later, a classmate named Mary Shaver brought to school a dusty, turn-of-the-century novel called *The Real Diary of a Real Boy*, by Henry A. Shute, and our teacher read it aloud to the class. Parts of it seemed impossibly old-fashioned (I was into skateboards and Spider-Man in 1966), but I loved the book anyway, and it inspired me to start keeping a diary myself. (See "My 5th Grade Diary" in my cartoon book *School Is Hell* for a taste of Matt Groening pre-teen goofiness.) *The Real Diary of a Real Boy* was set in New England during the 1880s, when the author was a boy, and mainly told of all the bad things the author did that got him into trouble (sort of like Bart Simpson). It reminded me of *Tom Sawyer*, one of my other favorite books that year.

I remember liking lots of books in the sixth grade. Mark Twain's *Huckleberry Finn* was even better than *Tom Sawyer*, and is still one of my favorite books. I started reading science fiction that year, but most of it I can't remember anymore. A couple have still stayed in my mind: *Red Planet*, by Robert Heinlein, and *Cat's Cradle*, by Kurt Vonnegut, Jr. *Cat's Cradle* has the shortest chapters (sometimes a page or less) of any grownup novel I'd ever read, and I think I dug it mainly for that. At the end of the sixth grade I got a hold of *Catcher in the Rye*, by J.D. Salinger, and that book changed my life. It gave me a good preview of what it was like to be a teenager, as well as being one of the funniest and at the same time saddest books I've ever read.

Anyway, you know all the reasons why reading is good: It enriches your life, helps you get better grades, teaches you new stuff, blah blah blah blah. The main reason I read is because it's fun.

Your pal,